MW01482371

THE 24-HOUR
DRESS CODE FOR
MEN

© 2004 Feierabend Verlag OHG
Mommsenstr. 43
10629 Berlin
Germany

Project coordination: Tina Flecken, Nicole Weilacher
Translation from German: Rebecca Holmes-Löffler
Editing: Lizzie Gilbert
Photo editing: Birgit Engel
Typesetting: Tobias Kuhn
Layout: Michael von Capitaine, Tobias Kuhn

Lithography: Farbo print + media GmbH, Cologne
Printing and binding: Druckhaus Locher, Cologne

Concept: Peter Feierabend

Printed in Germany

ISBN: 3-89985-055-6
61-10029-1

THE 24-HOUR DRESS CODE FOR
MEN

Birgit Engel

Feierabend

YOU CAN'T ESCAPE FASHION.
EVEN WHEN FASHION GOES OUT OF FASHION, THAT
IS FASHION IN ITSELF.

KARL LAGERFELD (*1938), GERMAN FASHION DESIGNER

IF THE CONDITION OF THE SOUL CHANGES,
THIS ALSO ALTERS THE APPEARANCE OF THE BODY
AND VICE VERSA:
IF THE APPEARANCE OF THE BODY CHANGES,
THIS ALSO ALTERS THE CONDITION OF THE SOUL.

ARISTOTLE (384-322 B.C.), GREEK PHILOSOPHER

What should I wear? What can I mix and match? What clothing suits me best and which style is right for a particular occasion? We are confronted with these questions and others like them every day. Today, fashion is everywhere. It is an integral part of our everyday lives. We use it to express our concept of ourselves and our bodies. The importance of fashion for men has grown steadily in this day and age in which clothing has become a distinguishing feature of individual personality. The days in which men's clothing all looked the same, was designed for functionality alone, and prohibited any expression of personal taste are long since gone. Functional style was a product of industrialization and the increasing importance of technology in the 19th century. A man was defined by his deeds, not his appearance or his clothing. The image of fashion changed over the course of the 20th century, however, with the rise of the leisure-time society and a more athletic lifestyle as well as the growing influence of the media and of the image of youth, who refused to accept traditional behavioral rules and clothing dictates. Today, men are once again displaying a real interest in fashion. It is not easy, however, to select clothing that suits one's own unique type and is equally fashionable at the same time. Fashion is complex and diverse. There is no longer such as thing a "the" trend. It has been replaced by multiple trends all popular at the same time. "The 24 Hour Dress Code for Men" shows what men can wear these days. And this not only refers to current fashion trends. Timeless basics and classics as well as items with cult status are essential for a tasteful wardrobe that expresses confidence in one's own unique style. The fascinating myths and unusual stories surrounding the rise of fashion are not just entertaining, they also provide a whole new (fashion) consciousness and sense of wearing adventure.

CONTENTS

	Thursday 05	Friday 06
7.00		
30	*Wake up, breakfast*	
8.00		
30	*Meeting, discussion of business plan*	
9.00		
30		
10.00		
30		
11.00	*Flight to Milan*	
30		
12.00		
30		
13.00		
30		
14.00		
30	*Golf with Roberto*	
15.00		
30		
16.00		
30		
17.00	*Beer at the Chiringuito*	
30		
18.00		
30		
19.00		
30		
20.00	*Scala, opera and then dinner*	

May 18. week

We
M
T
W
T

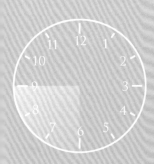

STYLISH IN BED AND AT THE BREAKFAST TABLE

OF BRIEFS AND TRENDY UNDIES

Briefs, underpants, drawers, boxer shorts, strings, tangas, and jock straps. Made of fine cotton or a high-quality, high-tech blend of materials. In plain black and white or in bright colors and patterns. Lots of moving and shaking has been going on in the world of men's underwear in the early 21st century. Underwear, previously worn for hygienic reasons only, has become a serious fashion issue. No longer must men content themselves with boring underpants. The world of men's underwear is highly varied as well as being tailored to the needs of its wearers. Whether for the fashion-conscious trendsetter, the sports enthusiast, or the more down-to-earth type. Underwear is available in any shape, fabric, or color design imaginable.

When we speak of men's underwear, we are referring in particular to underpants. Undershirts are becoming less common except among the older generation which is still wearing them today. At best, undershirts are worn under the outer layer of clothing on

very cold or very warm days only. Underpants are an essential, integral component of a man's wardrobe. They serve a hygienic and protective function. Underpants hold together what needs to be kept together on a man and provide protection against irritating seams. In addition, they also play an import role in fashion. The age of sloppy briefs and poorly fitting lust killers is now a thing of the past.

Underpants as we know them today were first developed at the beginning of the 20th century. The ancient Egyptians wore a loincloth, the Greeks a chiton, and the Romans a tunic. The Middle Ages brought with them breeches, a piece of fabric with a wrap-around waistband or belt. They were all items of clothing, a distinction between outer garments and underclothing is not possible, however. Members of the nobility wore a type of undergarment in the 17th and 18th century. For hundreds of years, the common people, however, contented themselves with

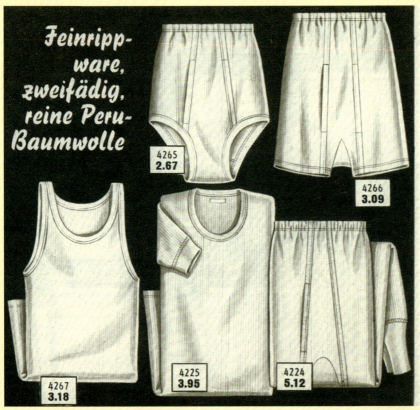

Feinripp-ware, zweifädig, reine Peru-Baumwolle

4265
2.67

4266
3.09

4267
3.18

4225
3.95

4224
5.12

Herrentrikotagen, zweifädige Feinrippware, sehr elastische, schmiegsame Qualität, aus gekämmten, reinen Baumwollgarnen, rein weiß gebleicht, besonders haltbar, sehr solide Verarbeitung und gute Paßform.
Reine Baumwolle.

Lieferbar in folgenden Formen:

Nr. 4265 Herren-Slip, laut Abbildung, mit Deckverschluß, Schrittverstärkung und auswechselbarem Gummizug im Bund und Gummizug im Beinabschluß.
Größen: 4, 5, 6 per Stück DM **2.67**

Nr. 4266 Herren-Schlüpfer, laut Abb., mit Deckverschluß, Doppelzwickel und breitem, auswechselbarem Gummizug im Bund.
Größen: 4, 5, 6 per Stück DM **3.09**

Nr. 4267 Herren-Unterjacke, laut Abb., ohne Ärmel, auch Turnerjacke genannt.
Größen: 4, 5, 6 per Stück DM **3.18**

Nr. 4225 Herren-Unterjacke, laut Abb., mit kurzen Ärmeln, Pulloverform.
Größen: 4, 5, 6 per Stück DM **3.95**

Nr. 4224 Herren-Unterhose, laut Abb., mit langen Beinen, Deckverschluß, Doppelzwickel und breitem, auswechselbarem Gummizug im Bund.
Größen: 4, 5, 6, 5/7 per Stück DM **5.12**

Bleached white, sturdy, and durable: briefs, undershirts, and underpants in double-thread fine-rib fabric made of pure Peruvian cotton from WITT Weiden, 1949.

a simple shirt, usually made of linen, that served as a shirt, nightdress, and underwear. The knee-length shirt was simply gathered up in the crotch—and *voilà*, one had a pair of underpants. Not until the rise of industrialization, machine manufacturing, mass production as well as changing social and economic living conditions did the underwear we know today become widely popular, affordable for everyone, and ultimately an essential part of people's wardrobes. Today, style no longer shows in the mere presence of underwear but in its careful selection.

In the mid-1930s, the Heinzelmann company in Stuttgart, Germany, developed so-called "piccolo underpants," a forerunner to modern men's briefs. Jockey, an American company, introduced the first Y-front brief to market in 1935. The model was patented and became one of the best-selling cuts. The traditional German company Schiesser developed the first fine-rib look in the 1920s and presented its legendary fine-rib underpants with fly after the Second World War. Just like the Y-front brief from Jockey, this model has meanwhile been copied countless times. During this time period, U.S. soldiers introduced the inhabitants of Europe to boxer shorts, which had already been available in the States since the 1920s and had originated as part of the summer uniform for infantrymen. Boxer shorts did not experience a surge of popularity in Europe until the 1980s, however. In a rainbow of colors and patterns, covered in Santa Clauses or hearts, they became the ideal present for any occasion.

Men's underpants began shrinking dramatically in size in the 1960s: the bikini brief was trendy for both men and women. In the 1970s, men wore wild patterns and color combinations.

Men's underwear first became a serious fashion issue in the 1980s, when underpants went from being regarded as an article of mere necessity to a status symbol. Lots of things have changed in the modern world of men's underwear. Having the right thing on underneath is important to the fashion-conscious man, as the unique feeling of well-being provided by carefully selected underwear enables him to master any situation with bravado.

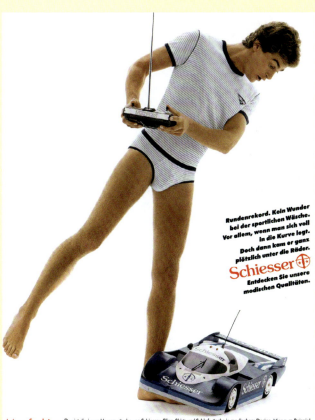

Rundenrekord. Kein Wunder bei der sportlichen Wäsche. Vor allem, wenn man sich voll in die Kurve legt. Doch dann kam er ganz plötzlich unter die Räder. **Schiesser** Entdecken Sie unsere modischen Qualitäten.

Men fashion Das ist die junge Herrenwäsche von Schiesser. Slips, Shirts und Schlafwäsche in modischem Design. Hier zum Beispiel unser sportliches Shirt, Modell-Nr. 5/821, mit passendem Slip, Modell-Nr. 5/828. Beides aus 100% Baumwolle. Übrigens: Schiesser-Produkte gibt es auch in der Schweiz, in Österreich, Belgien, Holland, Luxemburg, Frankreich, Italien und vielen anderen Ländern.

From the 1960s onward, men's underwear gradually went from being an article of pure hygienic necessity to becoming a "fashionable detail"; Schiesser advertising from the 1970s.

UNDERWEAR AT A GLANCE

When selecting underwear, wearing comfort and feel have top priority. There are no rules as to who should wear what kind of underwear. Simple, elegant underwear naturally looks better with a sophisticated suit jacket than an animal-print would. Boxer shorts tend to be too bulky for lightweight suit fabrics, briefs or simple underpants are preferable.

Experience has shown that most men like to wear just one kind of underwear. While some men wear only classic briefs, others prefer underpants or boxer shorts. The right size, perfect fit, and wearability are important features to be taken into consideration when purchasing underwear. A visit to a good undergarment store is well worth the while. After all, the most important factor in selecting underwear is that you feel good wearing it!

Briefs *are a popular style familiar to almost everyone. The brief is available in a wide variety of shapes and cuts. The classic brief is relatively compact and has a fly. The sports brief and the mini brief are somewhat smaller and tighter-fitting. They usually do not have a fly opening.*

Long underwear *has fallen on hard times. Yet the former lust killer now offers perfect fit and wearing comfort. And its advantages in cold weather should not be underestimated either!*

The word *tanga* *is Portuguese and means loincloth. The classic tanga is reduced to nothing but the waistband on the sides. The high leg holes permit lots of freedom of movement. The back is generously cut so that the rear end is well packaged.*

The *string tanga* *has the least fabric of any style of underwear. The first string tanga was created by French designer Paco Rabanne. A distinction is drawn between the regular string and the g-string. The latter has no fabric in the back, just a thin band.*

At first glance, the *jock strap* *appears highly erotic. In fact, however, this type of underwear is worn mostly for playing sports as it provides very good support and lots of freedom of movement.*

In terms of popularity, *underpants* *now come in a very close second after briefs. An increasing number of men prefer the short, tight-fitting underwear with more or less prominent leg pieces.*

Boxer shorts. *They were the absolute hit in the 1980s and are either dearly loved or energetically hated. Very few men are ambivalent when it comes to boxer shorts.*

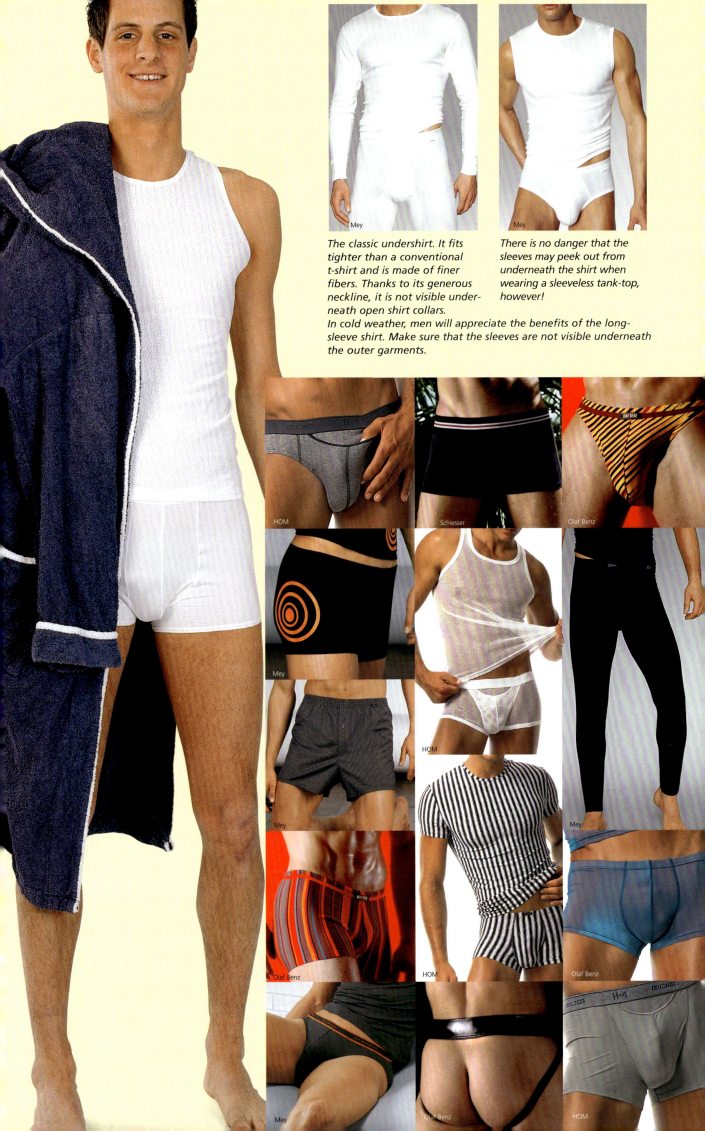

The classic undershirt. It fits tighter than a conventional t-shirt and is made of finer fibers. Thanks to its generous neckline, it is not visible underneath open shirt collars.
In cold weather, men will appreciate the benefits of the long-sleeve shirt. Make sure that the sleeves are not visible underneath the outer garments.

There is no danger that the sleeves may peek out from underneath the shirt when wearing a sleeveless tank-top, however!

Mey

Mey

HOM

Schiesser

Olaf Benz

Mey

HOM

Mey

Mey

Olaf Benz

HOM

Olaf Benz

Mey

Olaf Benz

HOM

The Right Size

Southern European sizes							
	1	2	3	4	5	6	7
English sizes							
Briefs (waist)	29	31	33	35	37	39	41
Shirts (chest measurement)	34	36	38	40	42	44	46
American sizes							
	XXS	XS	S	M	L	XL	XXL
Briefs	20/22	24/26	28/30	32/34	36/38	40/42	44/46
Shirts	26/28	30/32	34/36	38/40	42/44	46/48	50/52
Northern European sizes							
	2	3	4	5	6	7	8

INDIAN LEGACY

Colorful and imaginative, made of silky tricot fabric or cuddly terry cloth. The colorful pajamas of the 1970s, with bottoms resembling long underwear and tops featuring long sleeves and a rounded or V-shaped neckline, represent an era of highly successful classic nightwear. The two-piece pajama set could be found in every bed during this time. As it could just as easily be worn in front of the television set as in bed, this nightwear soon became homewear. Today, things in the bedroom look quite different. Ever since the T-shirt made its triumphal transition from simple undershirt to Number One fashion hit

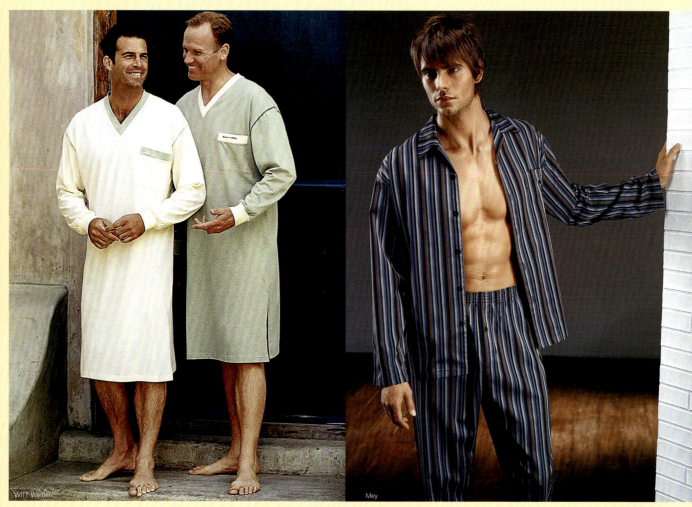

The selection of nightwear is extensive. Men can choose nightshirts made of soft terry cloth or go with classic pajamas. These have generously cut pants with a button closure and elastic waistband. The top is buttoned up and is vaguely reminiscent of a man's shirt.

(see Chapter 3), many men now wear it to bed instead of traditional pajamas. Paired with briefs or boxer shorts, it has become the most popular clothing for sleeping in. And those who want less fabric simply sleep in their underwear or without any clothing at all. In the Middle Ages, the latter option was the most commonplace. Until the 16th century, it was perfectly customary to sleep in the nude. The first written mention of a nightshirt is from around the year 1500 in Italy. Not until this time did people begin wearing nightshirts—and even then it was a privilege reserved for the few who could afford to do so. This nightshirt was a plain, wide, ankle-length shirt the original form of which has been retained until today as a men's nightshirt. From the 18th century onward, night jackets were also worn for additional warmth. In most cases, however, the common people had to use their shirts as outer garments, undershirts, and nightshirts at the same time. In 1850, colonists and traveling Europeans began wearing a type of pants popular in India and Persia. With an added jacket, the pants were soon being worn in the tropics and later in Europe and throughout the entire world. The original term for these pants, *pijama* (which essentially means "leg covering") soon became *pajama*, and the style itself rapidly surpassed the nightshirt in popularity as elegant sleepwear for men. Whether silk, cotton, flannel, or state-of-the-art fiber blends, pajamas are available in many types of fabrics, colors, and designs. They have meanwhile become classics for the most relaxed spot in the house.

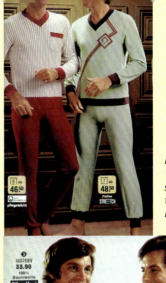

Men's pajamas from the 1970s and early 1980s with striped patterns, contrasting trimming, and fashionably interesting designs.

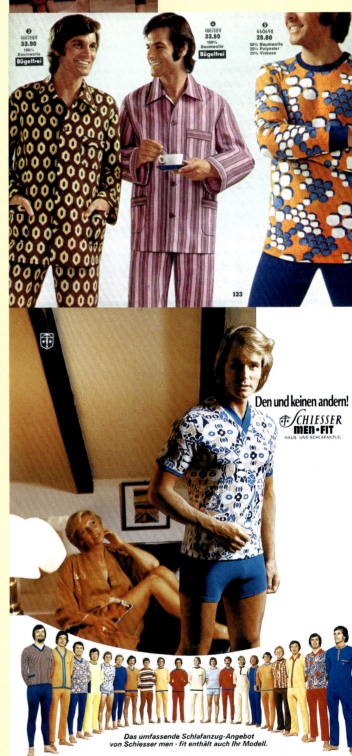

COZY AND COMFORTABLE IN PRIVATE

When a man wants to enjoy a leisurely breakfast after showering in the morning – regardless of whether on the weekend or in preparation for a long meeting in the evening—he doesn't want to spend this relaxed hour in business attire. Nor in pajamas either. The same holds true of the evening hours. The most enjoyable moment of the day has arrived, when good shoes can be exchanged for the favorite pair of slippers and the business suit for comfortable clothing. Everyone can choose exactly what they want to wear for these private hours. It should be comfortable clothing that is easy-care and of course looks good as well—because you then feel twice as good in it! A wrinkled T-shirt paired with sloppy old jogging pants just won't do. The age of one of the greatest crimes against fashion—wildly patterned jogging suits made of balloon silk—is thankfully dead and gone!

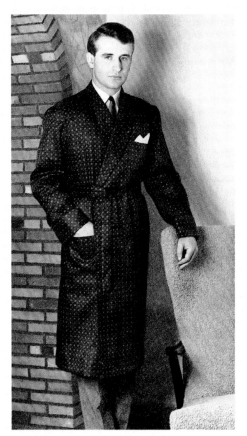

In the 1960s, men wore this elegant house coat, the so-called dressing gown, over their shirt and tie when at home in private.

The habit of wearing one set of clothes at home and another in public has been well established for hundreds of years already. From today's viewpoint, however, we would

In einem HOM-Hausanzug können Sie eine Menge machen. Sogar schlafen.

HOM-Hausanzüge für zuhause, und alles, was man vor dem Schlafengehen machen kann. Oder nach dem Aufstehen. Oder dazwischen. Sie sind hautfreundlich, pflegeleicht und aus mercerisierter Baumwolle mit Diolen®. In vielen Farben und Farbkombinationen. Auch in der Schweiz und in Österreich erhältlich. HOM Textilvertriebsges. mbH. Postfach 4131, 4 Düsseldorf.

HOM. Die männliche Linie.

Hom homewear from the 1970s. For the hours before going to sleep, after waking up, or in between.

regard the homewear seen in the days of yore as formal clothing. Yet back then it was considered casual. In the 17th and 18th century, men wore silk-lined brocade coats with Oriental patterns and shawl collars in the style of a caftan or kimono. Later, house

coats were made of silk or flannel, had buttons down the front and were closed with a belt. As an alternative to a house coat, men could also wear a house or smoking jacket. These flannel-lined jackets were made of wool or silk fabric, had wooden buttons or toggle fastenings as well as silk-edged quilted collars, and cuffs. From the 1950s onward, house coats were replaced by more versatile bathrobes. A beautiful bathrobe or dressing robe made of terry cloth, flannel, wool, or silk is perfect for the leisurely hours of the morning. Just like pajamas, the selection of robes is extremely broad. A bathrobe looks very elegant when color-coordinated with pajamas or made of the same fabric. Cotton or silk versions are most appropriate for summer, while warmer models made of terry cloth, velour, or pile fabric are better in winter. Those who dislike robes can turn to comfortable homewear or sportswear. When clothed in such comfortable apparel, a man is ready to make the very most of a leisurely evening.

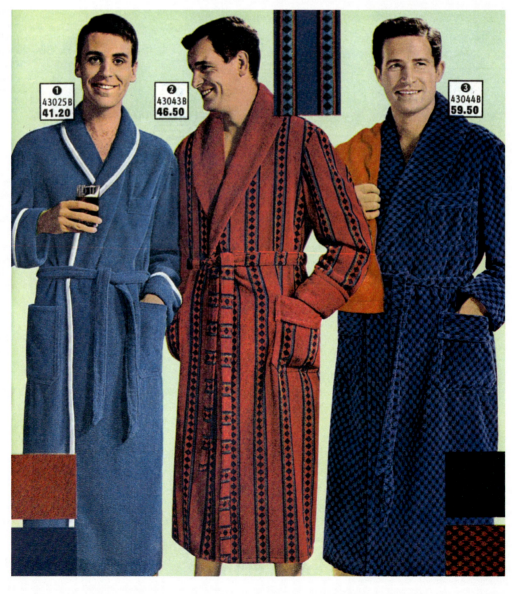

House and bath robes from the mid-1960s made of terry cloth or velour in stripes, subdued patterns, or solid colors, with shawl collar, cuffs, patch pockets, breast pocket, and tie belt.

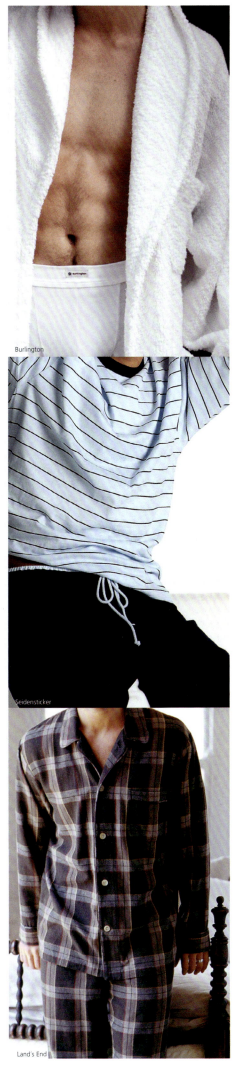

Burlington

Seidensticker

Land's End

Today's clothing for private time at home is highly varied in color, design, material, and style.

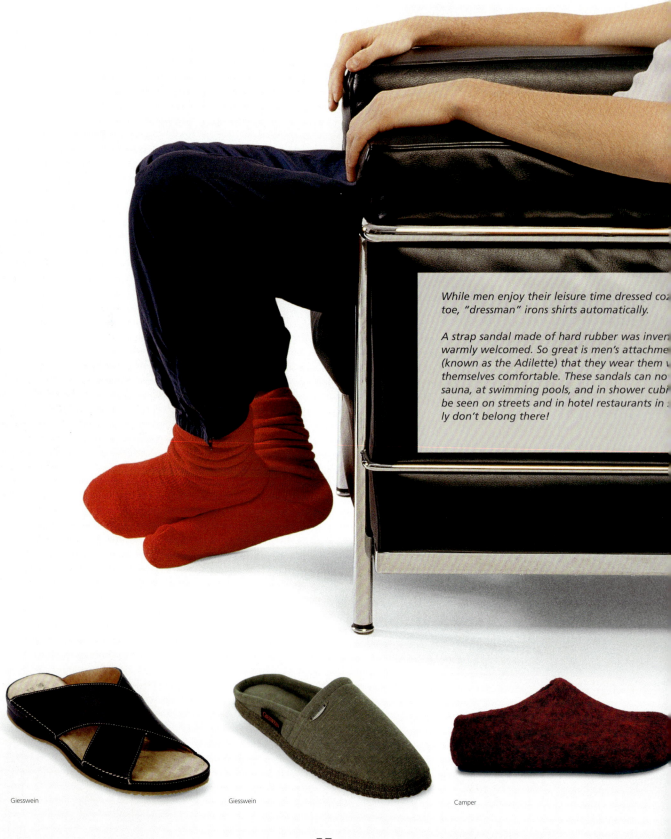

While men enjoy their leisure time dressed co[...]
toe, "dressman" irons shirts automatically.

A strap sandal made of hard rubber was inven[...]
warmly welcomed. So great is men's attachme[...]
(known as the Adilette) that they wear them [...]
themselves comfortable. These sandals can no [...]
sauna, at swimming pools, and in shower cub[...]
be seen on streets and in hotel restaurants in [...]
ly don't belong there!

Giesswein

Giesswein

Camper

...rtably from head to

...nd immediately
...ue footwear
...happen to make
...home, in the
...ately they can also
...l, and they certain-

"Dressman" Siemens-Pressebild

Land's End

Land's End

adidas

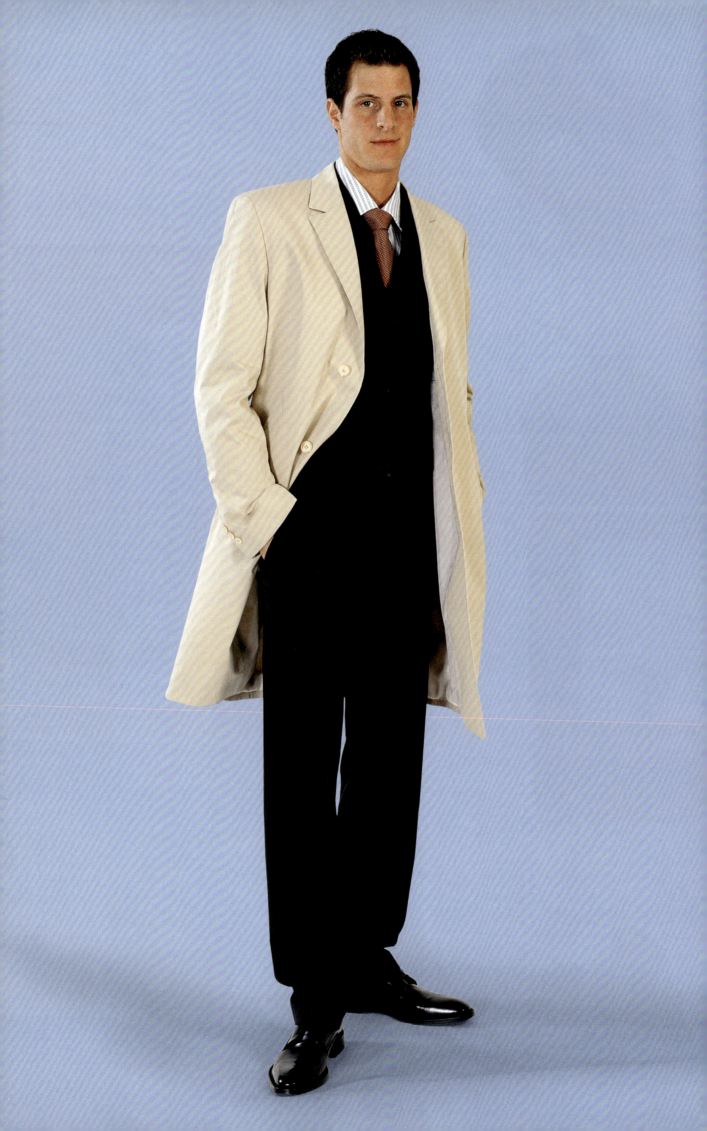

THE RIGHT
BUSINESS OUTFIT

2

THE PERFECT APPEARANCE

Without a doubt, the suit is the trademark classic outfit for men. Simple and uncomplicated to wear, it always ensures the perfect appearance. Clothing is instinctively read as a code. It reveals who a person is or wants to be and what he wants to communicate to others. Those who adhere to certain rules signal harmony with the group and emphasize common ground. This creates a certain basis for trust—a crucial factor for the future of a relationship in the business world. Despite the great range of freedom in fashion, the distinction between business and casual looks has been maintained until today. The relaxation of clothing rules and the introduction of *Casual Friday* have increased insecurity about the proper outfit, however.

There is no longer a global, standardized dress code. The textile requirements for the perfect business outfit vary from country to country. Southern Europeans and Latin Americans take questions of style and fashion very seriously. Colored two-piece outfits, short-sleeve shirts, or outfits without ties have no place in the everyday Latin American business world. "Casual" is not part of the Spanish businessman's vocabulary. He wears a dark suit jacket or fine pinstripes. The tie and shirt can be brightly colored, however. The situation is similar among Italians. A suit is an absolute essential, with perfect fit, elegance, and

quality topping the list of important features for underscoring the wearer's unique personality. The tie comes in a subdued color or simple pattern, voluminous knots are popular. In contrast, the British value understatement in keeping with the motto: style speaks for itself. The English businessman loves conservative, formal fashion in high-quality materials without any touch of individuality. The suit must be in subdued shades: black, anthracite, or dark gray as well as classic pinstripes or, if necessary, very dark blue. The suit should be worn with smooth leather lace-up shoes. Combinations are a no-no in the British business look, especially those with gold buttons and an emblem on the

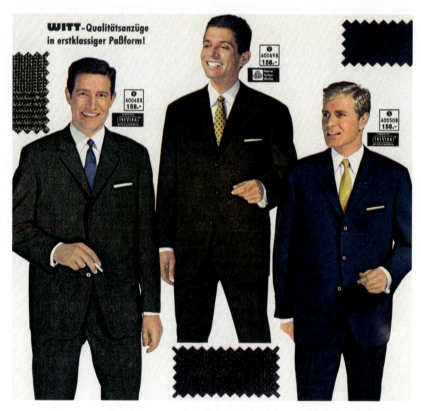

WITT-Qualitätsanzüge in erstklassiger Paßform!

Men's suits from the 1960s in glencheck, small patterns, or solid colors. The three-button jackets are made with a slit in the back, two inside pockets, and a comb pocket. The pants have a waistband, two hip pockets as well as a lining extending to under the knee.

jacket. Be careful of striped ties! A large number of diverse striped patterns stand for membership in a certain regiment, club, or

college. The Chinese see things very differently. In China, pragmatism dominates the otherwise fundamentally conservative business look. A suit jacket and tie are unnecessary in the summer, while it is perfectly okay to wear a sweater under the jacket in winter. Great value is placed on representative accessories such as luxury watches or tie pins set with gemstones. In the U.S.A., some companies even have written dress codes. It is no easy matter, however, to find one's way through the jungle of terminology the meaning of which varies from region to region. On the West Coast, *casual* refers to jeans and a T-shirt, while on the East Coast it is more likely to mean khakis, a polo shirt, and a blazer. When *business attire* is requested, a suit and tie are obligatory. *Casual business,* on the other hand, permits a combination with or without tie.

As different as national preferences may be, good and formal business clothing is as classic and as simple as possible. The perfect look consists of a suit in a pleasantly reserved color and pattern with jacket, pants, and vest (if present) in matching fabric, color, and pattern. Exotic accessories are inappropriate. This holds true at least for conservative sectors such as banks and insurance companies as well as for representative positions. In other fields, stylish mix-and-match fashion and cross-dressing are entirely possible. Men have the opportunity to interpret the rules according to their own personal style and individual taste in these sectors.

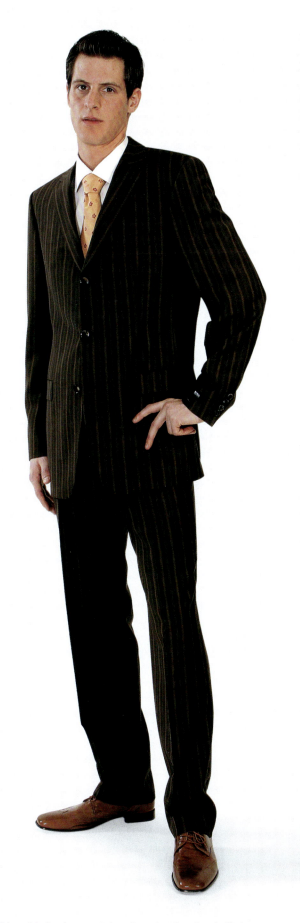

The fashionable business suit is tailored to be closely fitting. There are three-button and two-button jacket variants. On the latter, the buttons are positioned low and highlight the waist.

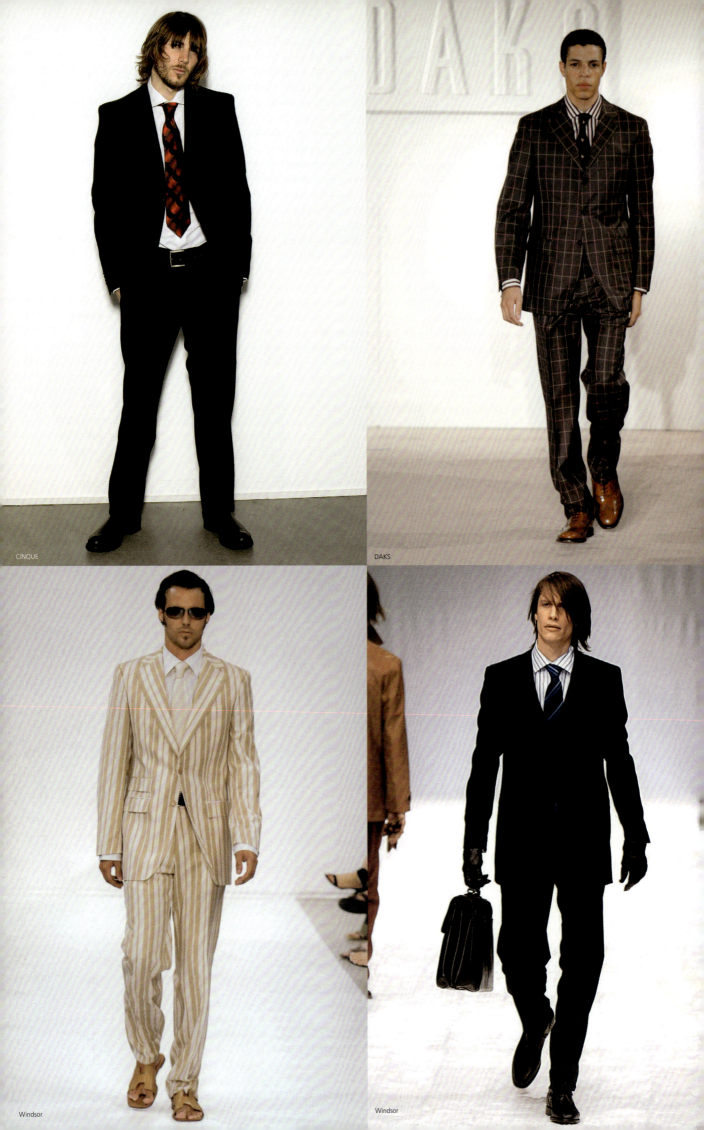

CINQUE

DAKS

Windsor

Windsor

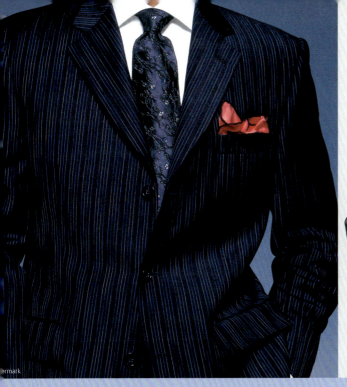
rmark

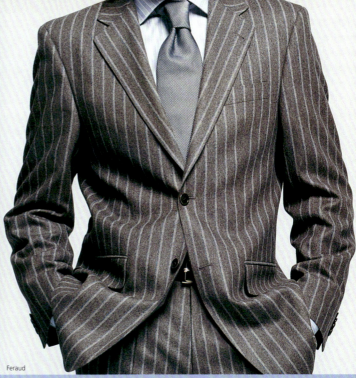
Feraud

The Pinstripe Suit

Stripes in all kinds of variations are currently a hot topic in men's fashion again, thus returning the pinstripe suit to the fashion forefront. It is among the all-time favorite suit styles and has repeatedly proved itself a timeless classic. In addition to its elegance, this flattering style also has a touch of something shady and rakish. And there is a good reason for this. During the age of prohibition in the 1920s, it was especially popular among members of the so-called underworld. It was later worn by elegant dandies such as Rudolph Valentino and Hollywood stars like Clark Gable. During the course of the 20th century, the macho suit evolved into a serious business outfit. But pinstripe suits are not all the same. When selecting material, remember that the suit is regarded as more serious the farther apart and the finer the stripes are. In other words, there is a big difference between the stripes worn by Al Capone and the fine stripes of a distinguished banker!

lier Torino

How Pants Got Creases and Turn-up Cuffs

King Edward VII is regarded as the inventor of the crease and turn-up cuff for pants. He was well known for his great interest in sports and his competency and flair in the world of fashion. During his lifetime, he was regarded as one of the best dressed men in England. According to legend, the crease was born at an English derby in 1909 won by Edward VII. It is said

that a strong rain caused the king's pants to lose their shape. A groom spread them out on a table to dry, weighted down with a board. The resulting creases pleased the king so greatly that he wore the pants to the victory ceremony, thus introducing the crease into fashion. The turn-up cuff is also closely tied to the ruler's athletic interests. During a horse race, he is said to have turned up the hem of his pants to protect them from rain and mud. This drew general attention, and the coincidence gave rise to a fashionable detail.

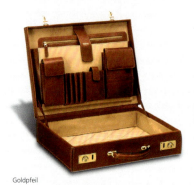

Goldpfeil

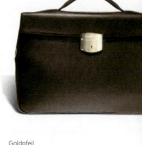

Goldpfeil

Goldpfeil

Suit Tips

◆ Acquiring a good wardrobe is not cheap. It is important to take your time in making a selection. Regardless of current trends, you should bear in mind a few simple rules for helping to find the appropriate suit.

◆ Wear the shoes, shirt and (if applicable) the tie you are planning to wear with the suit when shopping.

◆ The style, cut, color, and design of a suit are matters of pure taste. It is ultimately the fit that should be decisive in making a purchasing decision.

◆ In a well-fitting suit, a man's shoulders should blend into the shoulders of the suit when standing.

◆ When the arm is extended, the jacket sleeves should fit over the bone at the end of the wrist joint, slightly exposing the cuffs when the jacket remains buttoned up. If the sleeves have not been attached well, the shoulder area will be pushed too far upward.

◆ The back seam should not stretch when you move your arms towards each other with the jacket buttoned up.

◆ If the jacket is too large, it forms a completely straight silhouette when the wearer is standing and sticks out from the pants. The jacket should not be too tight either.

◆ The breast pockets should be well sewn and the pattern carefully matched with the rest of the suit.

◆ The collar should not stick out from the shirt. No creases should form where the collar is attached to the back of the shirt.

◆ The lapel must lay flat.

◆ The pants should fit loosely in the waist and the pant legs should not appear twisted.

◆ The pants should not be too tight. When you put your hands into the pockets, a cross-

The Dress Handkerchief

Men's tastes vary greatly when it comes to dress handkerchiefs. The accessory has enjoyed great popularity in some eras. Then the decorative handkerchief once again has become a little too much and men can easily appear overdressed with it. In the current trend to more classic, formal clothing, the dress handkerchief is again becoming a tool for expressing male creativity. Anything that appeals to the wearer is acceptable, but this does require a trained eye for the right combination.

In its early days, more than 150 years ago, the dress handkerchief was an additional pocket handkerchief which had to be sparkling white and clean. This principally held true until well into the 1950s. The dress handkerchief then vanished for a while, reappearing in the 1970s, color-coordinated and in combination with the necktie. Today, the handkerchief has its own independent existence and can be worn in a wide variety of colors or patterns according to taste.

Goldpfeil

Goldpfeil

Bugatti

wise crease should not form between the pockets and the behind part of the pants should not be stretched. Slightly wider pants are acceptable for a business outfit.

◆ If the pants have a crease, it should be straight and end over the middle of the instep of the foot.

◆ The quality of a suit's workmanship is also evident in the material and the attachment of the inner lining layers.

◆ The buttons should not be made of plastic and should match the style of the suit. When buttoned up, the jacket should not pull at the button panel and should have a straight drape.

◆ Large and stocky men appear even more compact in a suit with a wide, low lapel. The space between the lapels should therefore be proportional to the body.

◆ Unusual cuts and large patterns are especially conspicuous on small men.

◆ The fabric of the suit should be appropriate for all of the wearer's needs.

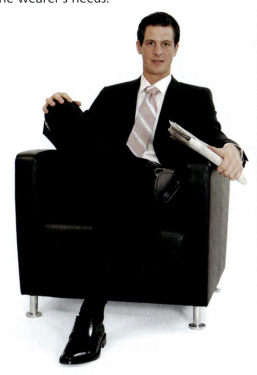

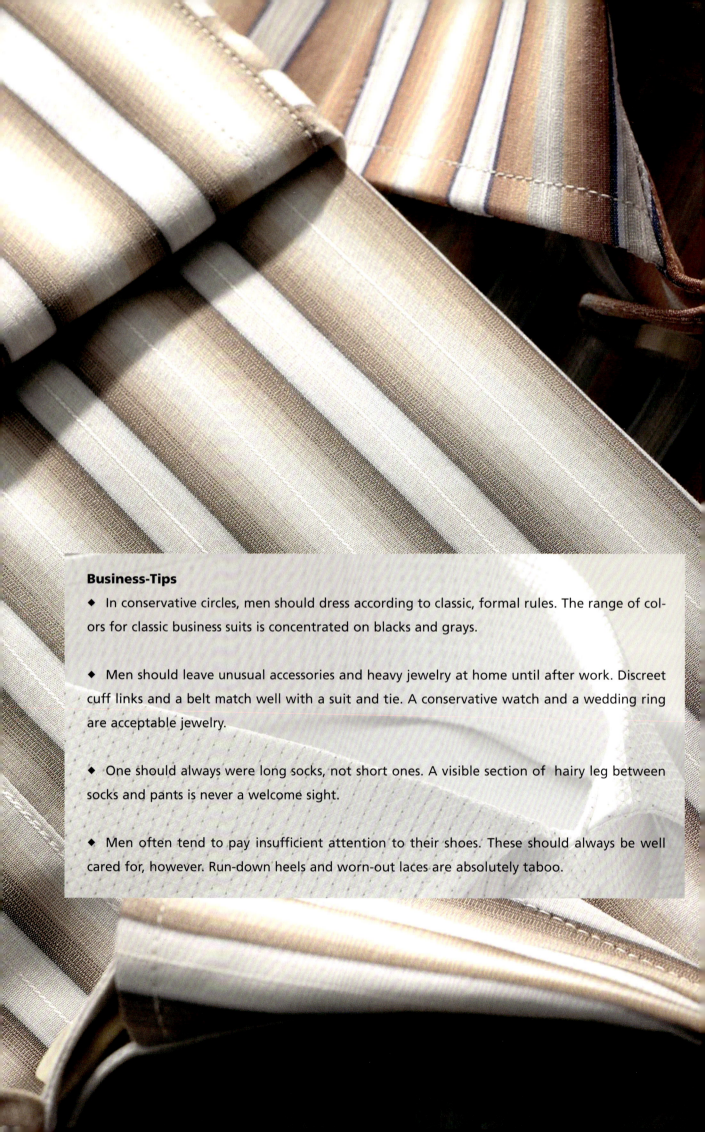

Business-Tips

◆ In conservative circles, men should dress according to classic, formal rules. The range of colors for classic business suits is concentrated on blacks and grays.

◆ Men should leave unusual accessories and heavy jewelry at home until after work. Discreet cuff links and a belt match well with a suit and tie. A conservative watch and a wedding ring are acceptable jewelry.

◆ One should always were long socks, not short ones. A visible section of hairy leg between socks and pants is never a welcome sight.

◆ Men often tend to pay insufficient attention to their shoes. These should always be well cared for, however. Run-down heels and worn-out laces are absolutely taboo.

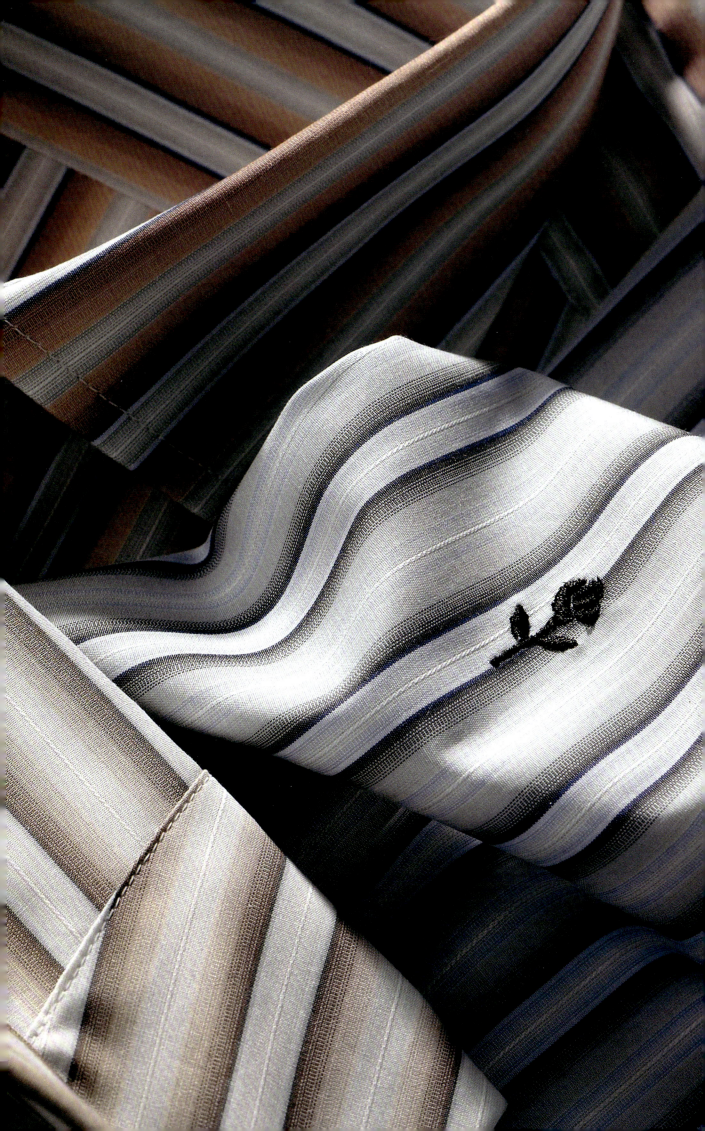

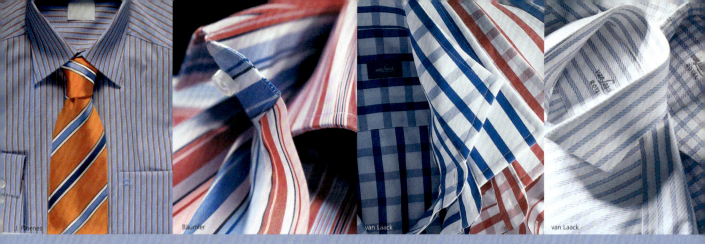

THE SHIRT

More than any other piece of clothing, the shirt is our close companion. It has existed since people began covering themselves and marks the dawn of the history of clothing. The modern shirt has little in common with earlier models. On the contrary, the earliest version was a large piece of cloth with a hole for sticking the head through. Separate cuffs and collars began to appear in the Middle Ages. A cord was drawn through the neckline, for example, over which a voluminous border puffed. This developed into the huge collars known as ruffs. Up to 17 (18.5 yards) meters of fabric were used in these collars. In fact, the collar is one of the most important stylish features of a shirt. It has always taken a wide variety of forms and shapes. One of the best known collars from earlier eras is the choker collar, a high stand-up collar with stiff

The cutaway collar draws attention to the tie knot.

The stand-up collar or folding collar has been worn almost exclusively with a tuxedo or tailcoat since the 1930s.

corners which could cut a man's throat. Right now, the world of men's fashion is dominated by the cutaway collar, also known as spread, shark, or Kent collar. The type of pulled-back collar permits the tie knot to stand out more. Men wore the shirt under their outer clothing until well into the 18th century. The collar and cuffs were the only features to vie for attention with the rest of the outer garments. Modern etiquette stills forbids shirt sleeves on formal occasions. The hallmark of modern shirts began gradually developing from the mid-19th century onwards, when the button panel and the yoke on the upper part of the back appeared, moving the bulk of the shirt further down on the body. The shirt became longer in the back than in the front so that it would not slip out of pants and no large

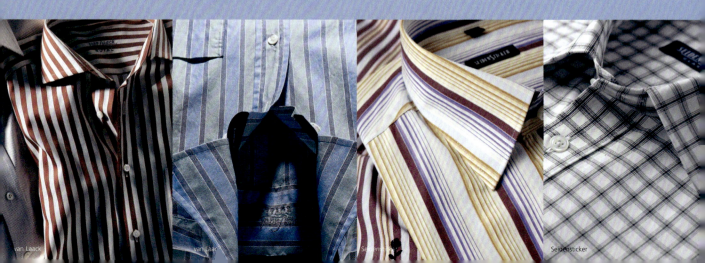

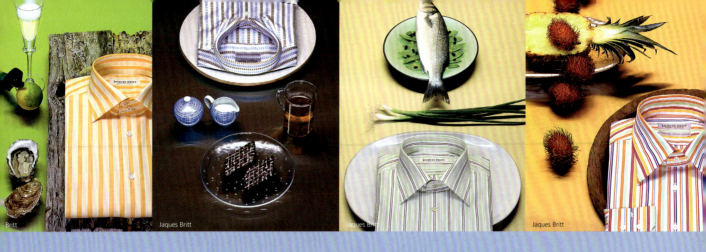

Britt Jaques Britt Jaques Britt Jaques Britt

quantities of fabric marred the appearance in the front. The turn-down collar then replaced the stand-up collar, which has appeared only on tuxedos or tailcoats since the 1930s. More colored and patterned shirts were available than ever before. However, the white shirt has always remained a bestseller and a classic when it comes to formal, proper clothing. There are several reasons why white has always been the shirt color of choice. White was an expression of prosperity and elegance. Only those who had enough money could afford to have their shirts cleaned on a regular basis. In addition, shirts

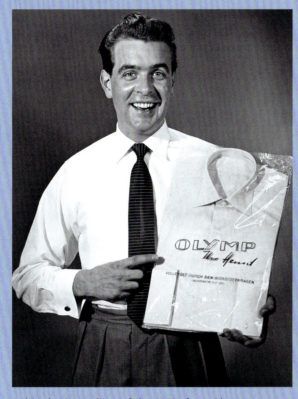

White business shirts of the 1950s from Olymp.

used to be made of linen and natural cotton. Both fabrics are easier to bleach. In addition, white creates a light-colored and reserved look, the so-called good first impression. The shirt for today's business man does not always have to be white. Neutral solid colors are very popular and striped patterns are also an important variation.

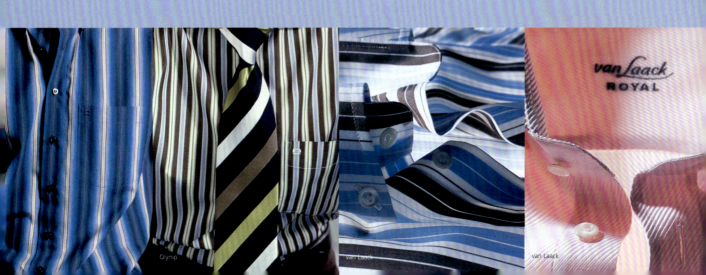

Olymp van Laack van Laack

TIE AND MAN—AN INSEPARABLE PAIR

Men's outfits are no longer subject to conventional and traditional constraints. The age in which it was unthinkable for men to go to the office or out in public without a tie is long since over with. And yet the handsome item of clothing is and will remain an integral part of

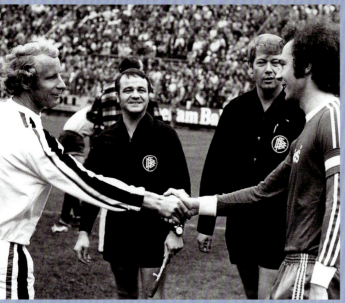

Borussia Mönchengladbach celebrated international victories in the 1970s. Above the team captain at that time, Berti Vogts, and the captain of Bayern München, Franz Beckenbauer.

men's fashion. This holds true for correct appearances in the business world and in public as well as for personal fashionable image as an expression of a chosen lifestyle. Once a year since 1965, the Deutsche Modeinstitut (German fashion institute) has been honoring a public personality with a convincing, fashionable appearance and who knows how to use the tie as a striking element of style. German Chancellor Willy Brandt was chosen as Tie Man of the Year in 1967, animal lover and zoologist Bernhard Grzimek in 1968, and the world champion show jumper Alwin Schockemöhle was honored in 1976. The award went to the soccer club Borussia Mönchengladbach in 2003, the first time it was awarded to a group. The Borussia players, who had enjoyed great national and inter-

national success in the 1970s, displayed persuasive overall styling and a professional fashionable appearance. Whether soccer, golf, or tennis, sports have meanwhile acquired a social importance that goes far beyond simple athletics. David Beckham is the best example of this. The famous soccer player has long since become a fashion icon and trendsetter when it comes to clothing and lifestyle.

The Mercenaries of the Sun King

The history of the tie leads us back to the age of the first Chinese emperor, Shih Huang Ti (260–209 B.C.), who had an army of 7,500 clay soldiers made for his grave complex. All of them wore a neck scarf.

Forerunners of the tie are also evident among the ancient Romans. A relief on the Column of Trajan in Rome, built in 113 A.D., depicts legionnaires with a neck scarf, the so-called *focale*. The expression focale most likely derives from the word *fauces* (Latin for neck, throat).

The next historical evidence of the tie comes from the 17th century, during which the courtiers of the Sun King (1638-1715) wore a so-called *cravate*. The term originally referred to the Croatian mercenaries which Louis XIV

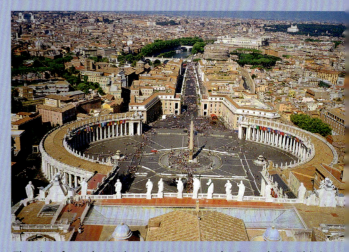

The view from the Vatican in Rome over the Eternal City. This is the site of the Column of Trajan, which depicts Roman legionnaires wearing the predecessor to the modern tie.

Tie made of pure silk double-warp fabric in a check pattern and a scarf made of printed foulard silk from the 1965 fall/winter collection by J. Ploenes.

hired during the Thirty Years' War and whose neck scarves attracted attention in France. The French adapted the item of clothing for their own purposes and dubbed it the *croate* after its wearers. This later became the French word *cravate*. Similar terms were then derived from this in other languages.

The tie, which was then a very expensive piece of cloth made of finest lace, became a standard part of men's wardrobes. During the French Revolution, the tie became an expression of political persuasion: revolutionaries wore black ties while the opponents of the revolution wore white ones. This was followed by the fashion of the *Incroyables*, whose large neck scarves were knotted in an unusual, eye-catching manner. In England, the elaborate scarves were known as neck cloths. One of its most legendary proponents was George Brummell. He was the trendsetter of his day and went down in history as "Beau Brummell."

Men's fashion became simpler and more down-to-earth during the course of the 19th century. When the stand-up collar disap-

peared around 1860 and men began folding down their shirt collars, the modern tie was born with the long necktie knotted in the front. In England, it was known as the four-in-hand for the knot on the reins of the four-horse carriage. In French, it was called the *regate*.

The crowning touches were added to the necktie in the 1920s when the American Jesse Langsdorf cut the tie fabric diagonal to the threadline and sewed the tie together from three parts. Good ties are still made this way today. It was then that checks, stripes, dots, and patterns began adding dynamics and color to the tie. In the years to come, ties would be wide or narrow, sometimes with subdued prints and sometimes in bright, trendy colors, depending on the current fashion. In the 1960s and 1970s, the tie became a symbol of narrow-mindedness and

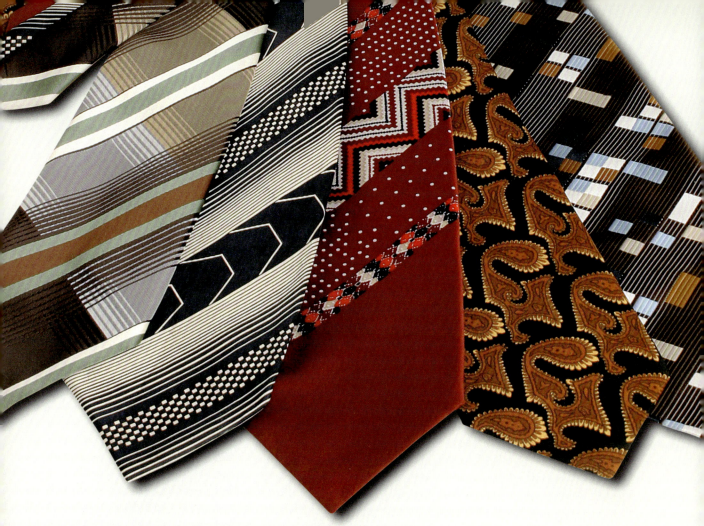

Wide ties by J. Ploenes from the 1960s and 1970s with a wide variety of patterns.

conservative thinking. Those who did wear a tie wore it up to 15 cm wide (almost 6 inches) and printed with wild patterns. The tie was brought back to life as a result of the social developments in the 1980s and became a favourite and essential item of clothing during the rise of yuppies. Today, the necktie as a fashion accessory is an indispensable element of style. It has featured innumerable patterns and motifs, countless colors and color combinations as well as a wide variety of materials during its history, but one thing has remained the same—its swordlike basic form.

The display window of a well-stocked men's store reveals that today's ties are highly colorful and varied.

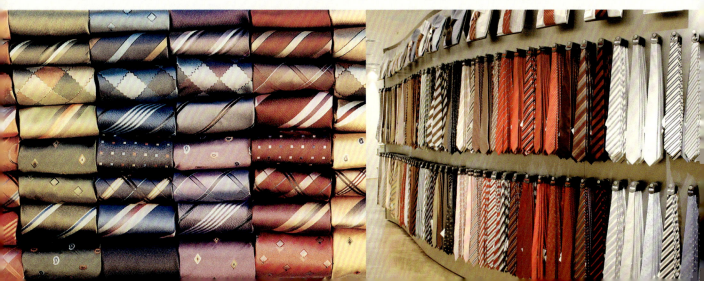

THE ART OF THE KNOT

Even the most handsome of ties loses its impact when the tie knot is misshapen. A man should therefore know how to tie a necktie properly, as it is critical that the knot be carefully and correctly formed. "One does not need a mirror to create a tie knot. Because a knot is made out of sight, one must feel it between the fingers," said the Duke of Windsor, who was well known not only because he chose to marry a divorced woman rather than ascend to the throne, but also because he was one of the most important influences on modern English fashion.

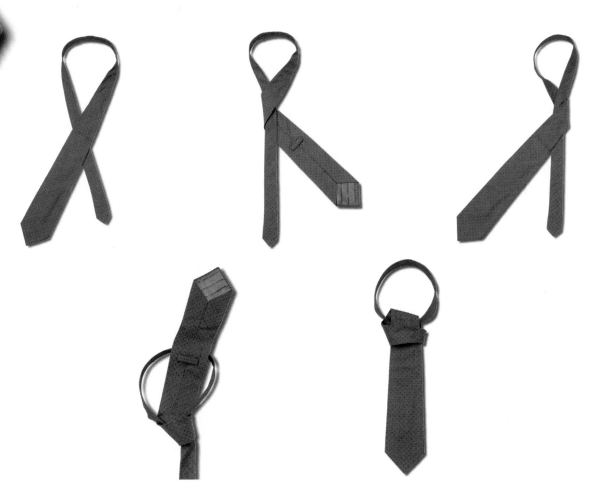

The Four-in-Hand

The standard knot is the four-in-hand or regate. This knot looks good with any type of collar form. In addition, its elongated knot shape makes the neck look longer.

This is how is works: the necktie is laid around the turned-up collar. Right-handers lay the narrow end over the left shoulder so that it hangs approximately one handbreadth over the waistline. Left-handers lay it over the right shoulder. The knot should be tied as close as possible to the neck so that it does not have to be pushed far.

The wide end is wrapped around the narrow end once and inserted through the loop thus created from behind. The knot has then been tied and need only be pushed to the appropriate height. The narrow end in the back can be run through the label.

The Windsor Knot

Make sure that the knot looks wide and voluminous on shirts with collar corners that are far apart such as the cutaway collar (spread, shark, or Kent collar). When a tie has the proper thickness, the required volume of the knot can be attained with a simple four-in-hand. Otherwise a simple or half Windsor knot, which is basically nothing more than a standard knot with more volume, is advisable.

One should bear in mind that the narrow end should be more than a handbreadth over the waistline for the Windsor as more fabric is needed.

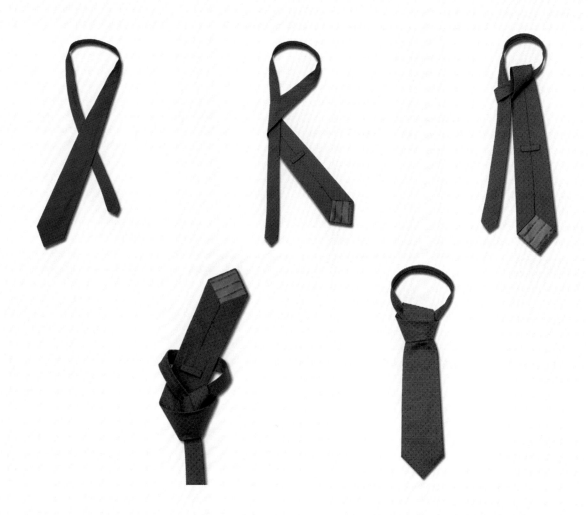

Fit to be Tied in Any Language

ALBANIAN	KRAVATE	FINNISH	SOLMIO	POLISH	KRAWAT
AMERICAN	NECKTIE	FRENCH	CRAVATE	PORTUGUESE	GRAVATA
ARGENTINE	CORBATA	GALIC	TAIDHE	ROMANIAN	CRAVATA
BASQUE	LOTU	GREEK	LAIMODHETIS	RUSSIAN	GALSTUK
BRAZ. PORTUGUESE	GRAVATA	HUNGARIAN	NYAKKENDÖ	SENEGALESE	CRAVATE
CHINESE	LING DAI	ICELANDIC	BINDI	SERBIAN	KRAVATA
COLUMBIAN SPANISH	CORBATA	INDIAN	GALE KA THANDA	SLOVAKIAN	KRAVATA
CREOL	CRAVATE	INDONESIAN	CRAVACHE; DASI	SPANISH	CORBATA
CROATIAN	CROATA; KRAVATA	ITALIAN	CRAVATTA	SWEDISH	SLIPS
DUTCH	DAS; STROPDAS	JAPANESE	NEKUTAI	TURKISH	KRAVAT
GERMAN	KRAWATTE	KOREAN	TIE	UKRAINIAN	KORBACS
ENGLISH	TIE; NECKTIE	LATIN	FOCALE	VIETNAMESE	CA VAT
ESTONIAN	SIDE	NORWEGIAN	SLIPS	INTERNET	:-)=>

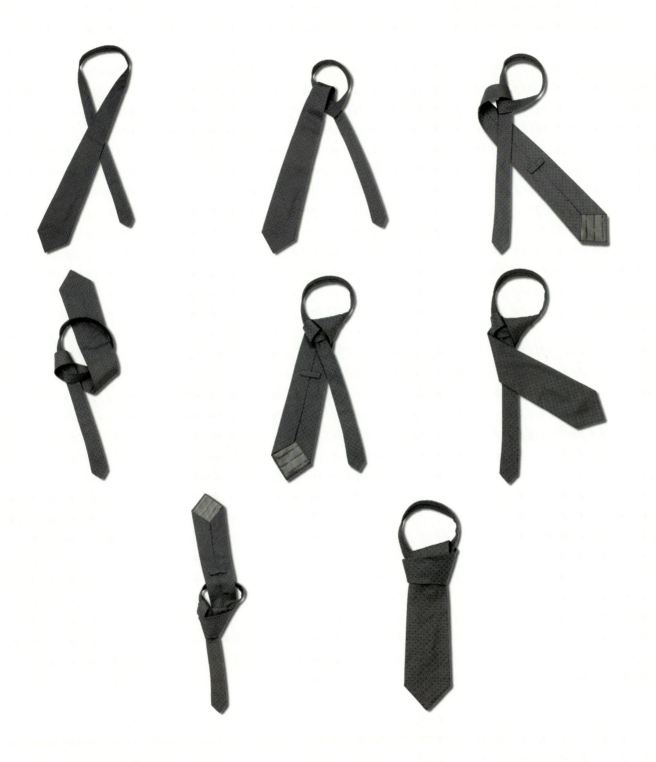

The simple Windsor knot

"A well-tied tie is the first serious step in life," wrote the English author Oscar Wilde (1854–1900). The Windsor appears quite complicated at first glance and in comparison to the four-in-hand. Yet one must only wrap the long end around the short end one more time. This will give the knot much more volume.

With a little practice and patience, this tying technique will turn out just as easy to master as the four-in-hand.

A well-tied tie is the hallmark of a man of the world. A voluminous knot such as the Windsor goes well with a shark collar.

van Laack

J. Ploenes

J. Ploenes

van Laack

J. Ploenes

J. Ploenes

van Laack

van Laack

J. Ploenes

J. Ploenes

J. Ploenes

van Laack

van Laack

J. Ploenes

van Laack

J. Ploenes

TieCare
aufgedreht gut gepflegt

J. PLOENES

Die kravate

Ties need to be well cared for. With a special roll-up mechanism, TieCare guarantees perfect tie storage at all times.

TIE TIPS

◆ Tying a necktie requires great care and attention. Loosely tied knots that convey a certain attitude of nonchalance are currently fashionable. Knots that have been pulled too tight and have a squashed appearance never look good.

◆ Before purchasing a tie, try it on. Make a knot and determine how well you can work with the tie.

◆ If you want to know if the tie you have selected has been cut well, take the tie in one hand and hold it up high. If the tie does not twist around, it has been cut well.

◆ On good ties, the lining on the back is not sewn in on the edge but somewhat more to the inside instead.

◆ Elasticity is another sign of quality. Pull on both ends of the necktie. A lack of elasticity is a sign of inferior quality.

◆ Men with long torsos should not use knots which require lots of material. Nor should they purchase extra-long ties.

◆ The knot should be undone and the tie smoothed out before being put back into the closet in the evening.

◆ If possible, you should always hang ties up. If you need to put them in a drawer, the front side of the tie should never be folded. One possibility is to loosely roll the tie together. When you are traveling, the loosely rolled tie can be placed in solid shoes. It is also safe to place it between sturdy pieces of clothing such as jackets. Be careful, however, not to crease the wide end. A necktie case or tie box are good solutions.

THE RIGHT JACKET OR COAT

The right jacket or coat complete the perfect outfit and add the crowning touch. But naturally only if the piece harmonizes well with the rest of the outer clothing.

Of course one can do without a coat or jacket at certain times of the year, such as in the hot and dry summer months. Otherwise, however, this item of clothing is just as much a part of a man's overall styling as anything else is. There are different reasons for this: when clothing—in particular outerwear—matches the occasion, it communicates what a man is currently doing. Perhaps he is on his way to the office or on a trip, just enjoying his leisure time, or dressed for a festive event. In addition, the coat serves a protective function against cold, wind, and rain. The coat or jacket offer symbolic protection as well. Not until a man has taken off this piece of clothing has he arrived and is he ready for communication.

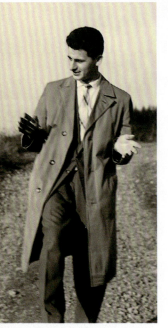

Outfit from the early 1960s.

The mantle, its name deriving from the Latin *mantellum*, was a sleeveless cloak, worn as an outer robe until well into the 18th century. This was when the coats which served as the models for today's version were first developed. Timeless classics include the caban jacket or the trench coat.

In past years, coats were not a big deal in the world of men's fashion. Now they are back again, with narrow, tight-fitting cuts and in knee length. Single-breasted coats in striking silhouettes and short lengths are advisable for those who prefer a classic look.

The Trench Coat

The British cloth expert Thomas Burberry, born in the county of Surrey in southeastern England in 1835, had a vision of a weatherproof coat. He developed an equally wind-resistant, waterproof, and breathable fabric which he called *gabardine* and used it to create a piece of clothing that would go down in fashion history as the trench coat. Used as a uniform coat in the First World War to protect the British infantryman from wind and weather in the trenches, it advanced to become a universally popular civilian all-weather coat in both Europe and America during the 1920s.

The trench coat has remained a permanent hit in both men's and women's fashion until today and it doesn't appear as if this will change anytime in the foreseeable future. Variations in fabrics and cuts continually incorporate the respective fashion trends of the moment, but the basic shape of the trench has remained unaltered until today.

The original Burberry has shoulder pieces, a broad turn-down collar and a broad lapel, front and back yoke, a wide belt with metal eyelets and clasps, adjustable sleeve tabs, and paneled pockets. It

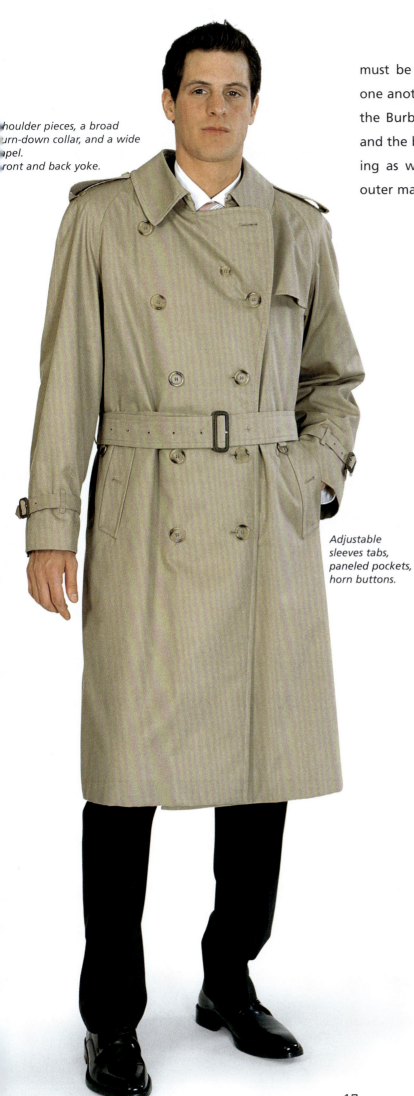

...houlder pieces, a broad ...urn-down collar, and a wide ...apel. ...ront and back yoke.

must be possible to button the yokes over one another in the front. Other hallmarks of the Burberry coat include the horn buttons and the button-in Burberry check flannel lining as well as the dark beige color of the outer material.

Adjustable sleeves tabs, paneled pockets, horn buttons.

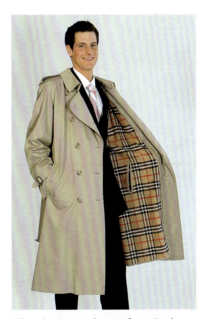

The classic trench coat from Burberry with the world-famous check pattern, the so-called Burberry house check.

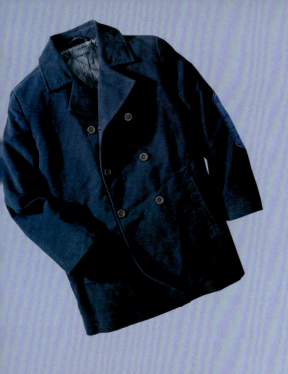

The Gaban

The caban jacket (from the Arab word *gaba*) is a timeless classic, a functional, hip-long, double-breasted jacket with broad yoke and prominent pockets. It originated as an Arabian robe that arrived in Europe by way of Sicily in the 14th century. In the early 19th century, the caban was worn as a loosely cut men's coat with pointed cap. In the 1920s, it developed into a short coat ending just above the thighs, worn over the business coat and also known as a surcoat. In the

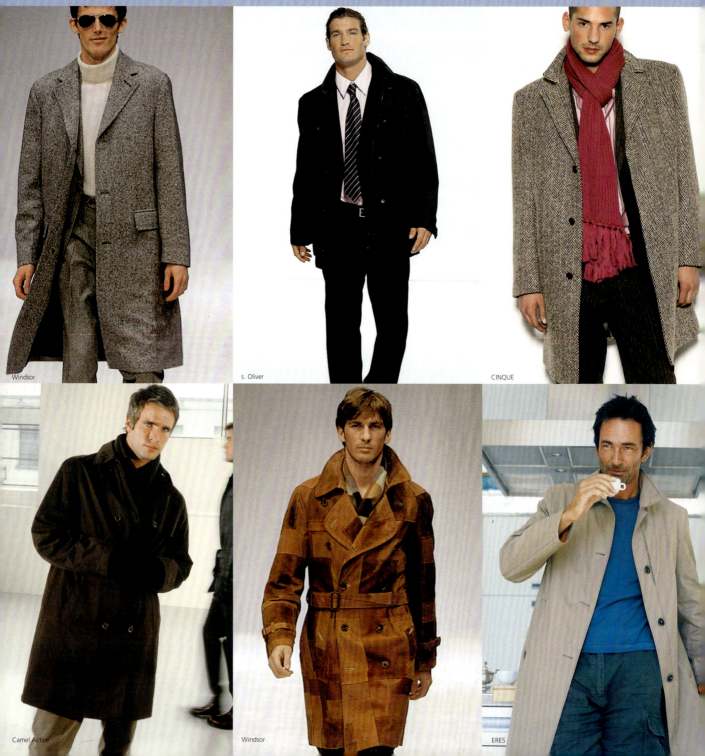

Windsor

s. Oliver

CINQUE

Camel Active

Windsor

ERES

1960s, the slightly fitted double-breasted jacket with broad lapel and pockets was worn mostly in dark blue, resembling a marine-style jacket. Camelhair colors became popular in the early 1970s. Today, the classic, simple caban jacket is available in a variety of styles and fabrics.

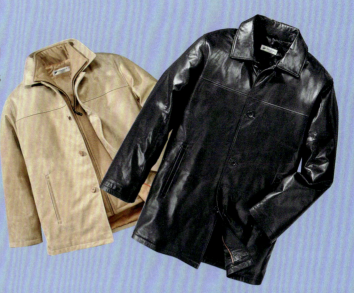

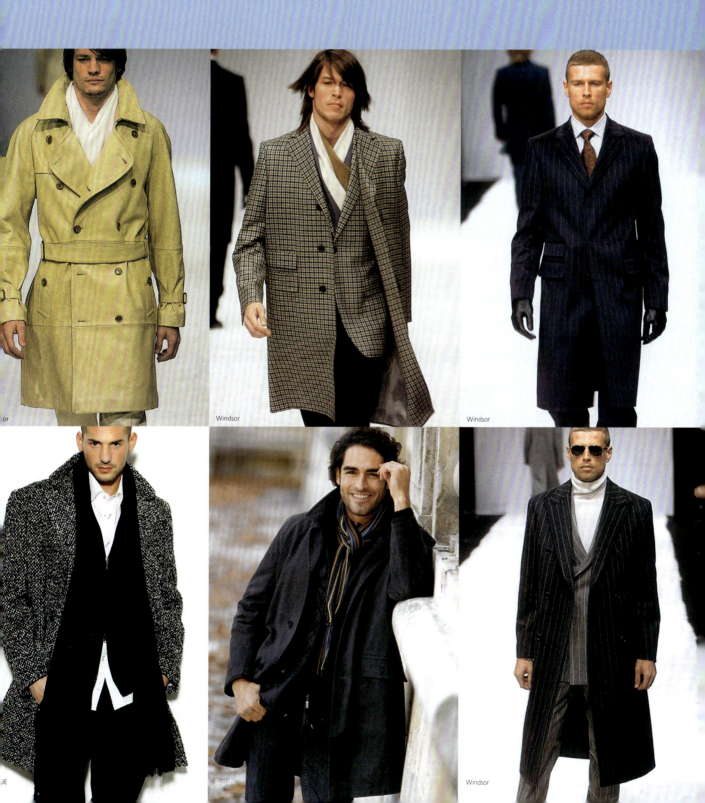

TREAT YOUR FEET!

There are fashion rules that cannot be found in any manual but should be heeded nonetheless. One of these is the unspoken rule in regard to the item of clothing closest to a man's legs—the sock. Men should note the following: socks should be long enough to cover a man's hairy calves when he is sitting or standing, as this would ruin the outfit's perfect overall appearance. Socks should match the rest of the clothing in terms of color, pattern, and material.

Men can choose between wool, cotton, silk, and a variety of mixed fibers. The fabric of the outer clothing, and possibly the season of the year as well, determine which sock material is most suitable. An elegant suit naturally calls for

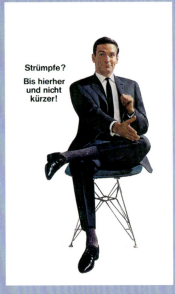

Socks? Up to here and no farther. Advertising from Falke in 1962.

Bared men's legs? Long socks are the remedy!

robust material. Single-color socks are easiest to combine with the rest of the outfit. Socks with patterns on them are more difficult, as the pattern must harmonize well with the outer clothing. Men who have difficulties combining colors and patterns should take the safe bet and use single-color socks. One must be careful to avoid too stark a color contrast to the rest of the clothing. White socks are thus an absolute no-no with a dark suit and dark shoes. Socks with worn-out heels, stretched out elastic, or faded colors naturally have no place in a well-groomed man's wardrobe. Those who prefer moccasins or sneakers in summer need not wear socks at all. Socks are obviously taboo with sandals.

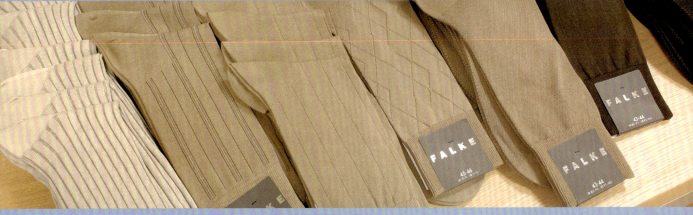

fine silk socks, not ones made of coarse wool. Yet these same silk socks would be highly unsuitable with pants made of a heavy,

Kunert

Kunert

Kunert

Kunert

Kunert

Falke

GETTING DOWN TO BUSINESS IN THE RIGHT SHOES

The perfect shoe for business clothing is conservative and high quality. Those who believe that shoes are merely a fashionable accessory should think again. Appropriate, well-cared-for shoes are an integral part of every perfect, stylish outfit. A good pair of shoes naturally can't make up for a poorly chosen outfit, but bad shoes can easily ruin an otherwise perfect outfit.

The shoe must fulfill numerous demands. It should be in keeping with fashionable trends but comfortable enough that one can wear it for a long workday. Manufacturers are thus currently favoring extremely soft types of leather and slightly flexible soles. In terms of shape, men can choose between pointed, squared, or rounded shoes, between boots, slip-ons, or lace-up shoes.

The different shoe styles and variations that are offered in every season of the year make it easy to lose sight of the big picture. In reality there are only a few basic forms to which nearly all men's shoes conform:

Men with a flair for style and fashion have a wide selection of appropriate shoes to choose from. Those who aren't quite as sure of themselves should wear a black lace-up shoe such

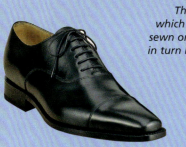

The Oxford is a lace-up shoe on which the leather for the toe-cap is sewn onto the side pieces, which are in turn held together with shoelaces.

Görtz

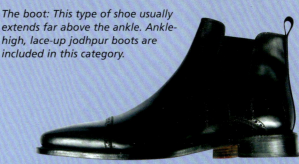

The boot: This type of shoe usually extends far above the ankle. Ankle-high, lace-up jodhpur boots are included in this category.

Lottusse

The Derby: This type of shoe is also known as the Gibson. The leather on the toe-cap continues under the side pieces and forms a tongue over which the laces are tied.

Hugo Boss

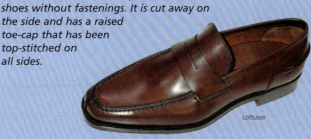

The moccasin: The slip-on moccasin was originally made of suede and is the predecessor to all forms of shoes without fastenings. It is cut away on the side and has a raised toe-cap that has been top-stitched on all sides.

Lottusse

The Brogue: It resembles the Oxford but is decorated with a perforation pattern on the spot where the top and side leather pieces meet.

Lottusse

The sandal is an open shoe held on the foot by straps.

Görtz

as the Oxford or the Derby with their business suit. These shoe models are formally correct with a suit, so one can't go wrong. When shopping for shoes, men should always take the texture of the leather into account. A

old one shrouded in legend. As was the case for all medieval crafts, the shoemakers joined together to form a guild. One of the first was founded in England: The Guild of Cord-wainers was a name derived from the Spanish

The traditional Lobb company in St. James's Street No. 9 in London.

sporty suede shoe is just as unsuitable with a fine suit as a thick-soled Brogue would be.

The upper material of choice for men's shoes is goat leather, patent leather, suede, or brushed pig leather. Extravagant shoes are currently limited almost exclusively to women's fashion. This was not always the case, however. In past centuries, lavishly deco-rated shoes were just as popular among men. Men wore rosettes made of pearls and gold on their shoes. These were later replaced by shoe buckles, which acted as a status symbol signalizing the wealth, position, and taste of their wearer in the mid-18th century. Men of the world had up to fifty different types of buckles—extending from gold-plated silver for daily use all the way to buckles set with gemstones for special occasions.

The man of the world naturally prefers shoes made of top-quality leather, for the most part handmade. The craft of shoemaking is a very

city of Cordoba, which in the Middle Ages produced the best leather. Today, custom shoemakers can only be found in the most important fashion capitals. One name that always comes up when talk turns to custom-made shoes is John Lobb Ltd., London. For generations, the Lobb family's traditional company has been making shoes for the English aristocracy and the European nobility. American customers have been playing an increasingly important role since the 1920s. The list of John Lobb Ltd. customers reads like a who's who directory of the most successful personalities of the 20th century.

Those who won't or can't spend their money on custom-made shoes can buy them off the rack. Mass production has now reached a level of such perfection that men can easily achieve a perfect look with such shoes as well.

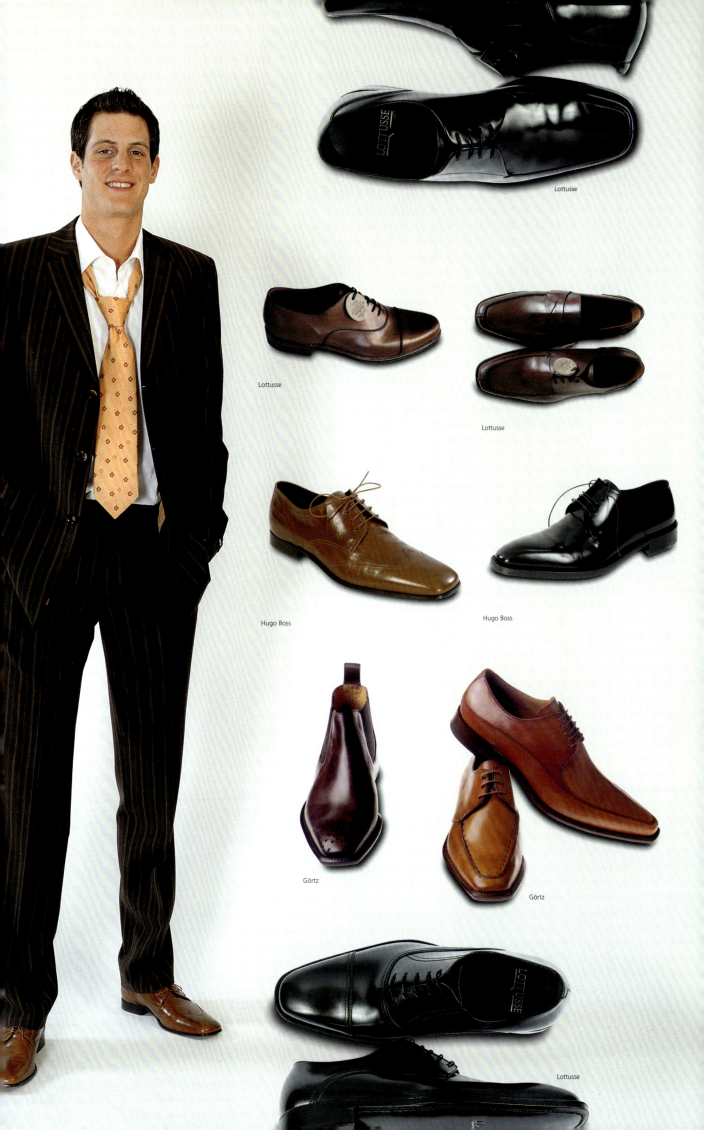

Lottusse

Lottusse

Lottusse

Hugo Boss

Hugo Boss

Görtz

Görtz

Lottusse

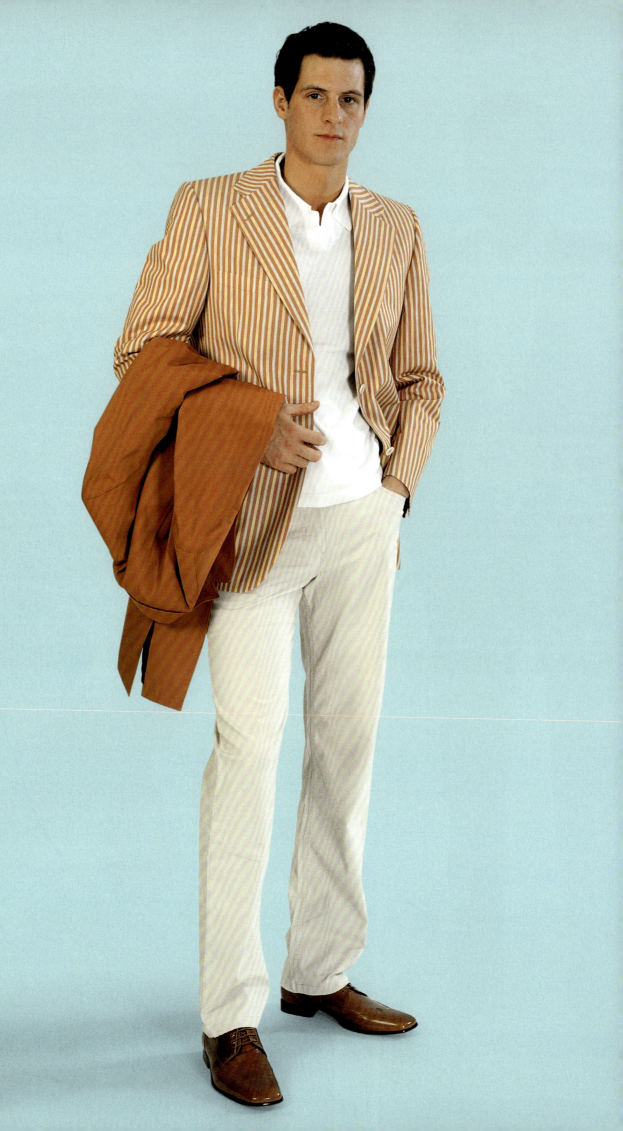

COMFORTABLE
AND FASHIONABLE
ON THE GO

CASUAL IS TRENDY

The age of industrialization was the starting point for a development which brought with it permanent changes in the way people live. Increasing prosperity, regulated working hours, and secure income gave people more free time away from career responsibilities, and as a result leisure time became its own independent part of life. Because lifestyle and fashion are closely interlinked with one another, this development gave rise to leisure-time clothing. This term seems somewhat old-fashioned from today's viewpoint, and there are meanwhile other terms which better describe these areas of fashion. Back then, however, leisure-time clothing was nothing more than a synonym for casual and the opposite of conventional or formal clothing. From club jackets to jeans, from sweaters to khakis—all of these items of clothing are products of this so-called leisure-time fashion. Most originated in the field of sports clothing, such as the blazer, or from the world of work clothing, such as sweaters or jeans. Today, they are regarded as indispensable basics and have gone down in fashion history as classics. Men like to wear the so-called casual look on many occasions, such as when traveling or to informal events and get-togethers. The casual look refers to a comfortable and relaxed but by no means sloppy style which is worn as an alternative to formal business attire. Casual Friday, a product of the New Economy era, is a good example of when such clothing is worn. A man can wear the casual look when formal business attire is not obligatory and he wants to look leisurely and relaxed but not overly sporty. A number of pieces can be combined here, such as a sports coat with casual pants, knitwear with chalk-stripe, five-pocket pants and a slim-fitting short coat or so-called urban parka on top. At the moment, great emphasis is being placed on clear, figure-hugging lines. The selection of colors available is strong, but not loud or flashy. The outfit bespeaks of reserved elegance or wild romanticism and always has a casual charm with a relaxed touch. Men can set their own individual focal points according to their personal taste and style. If a man prefers to dress especially casual, he can combine formal items of clothing with very expressive sporty elements. If he wants to emphasize the formal, correct style, he can restrict himself to a few, conservative accents.

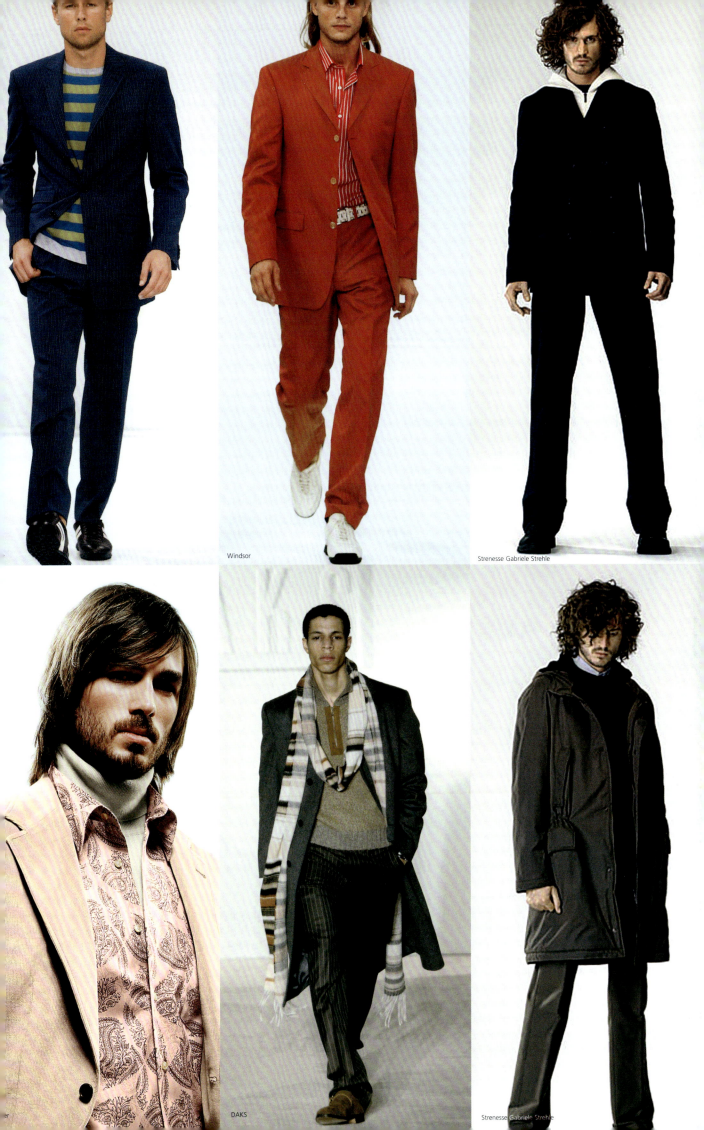

Windsor

Strenesse Gabriele Strehle

DAKS

Strenesse Gabriele Strehle

The Blazer—Something for Everyone

Like many other items of clothing described in this book, the blazer is one of the all-time fashion classics. A man should definitely have one in his closet as it is extremely versatile

Double-breasted club jacket with patch pockets and side slits from the 1960s.

and, combined with other pieces, can be worn on nearly any occasion. It always creates a good figure—whether with jeans and a T-shirt during leisure time or paired with a shirt, tie, and chinos for informal occasions. For those who are not yet acquainted with the piece, the blazer is a single- or double-breasted buttoned jacket with a collar and

Combination with blazer from DAKS, 2004.

lapel. The classic blazer is hip-length and has patch pockets and gold buttons. Fashionable blazers can vary in cut and style. Naturally there are also stories about how the blazer became so well-established in the world of fashion. Supposedly, the double-breasted blazer was created when the captain of the HMS Blazer clothed his crew in short, double-breasted jackets to which he had added gold buttons for a fleet parade in honor of Queen Victoria.

The British monarch was so pleased by the shining outfits that she had her whole fleet outfitted in them. The single-breasted blazer became popular under the name club jacket, which gives an indication of its origins. This was the jacket used by British rowing and cricket clubs, which were already demonstrating membership in a certain group in the late 19th century with their uniform outfits. The club emblem on the breast pocket, and often on the buttons as well, was obligatory. There are thus two possibilities as to how the name "blazer" could have been derived: to blaze = shine or burn brightly and fiercely; blazon = heraldic shield, coat of arms.

The Duffle Coat—A Collector's Item with Lots of Fans

The duffle coat is unmistakable. It has never been banished to fashion exile and is currently trendy once again. The much-beloved, all-purpose coat got its name from the Belgian city of Duffel in which a beige-colored wool fabric called *duffild* was produced. The cut itself is thought to have originated from the so-called Polish coat, a frock-coat-like overcoat that was extremely popular in the first half of the 19th century.

Like the trench coat, the duffle coat also became well known through a wartime event. During the landing of the Western Allies in Normandy on the "longest day," June 6, 1944, the commander-in-chief of the military troops Bernhard L. Montgomery attracted attention with his rather unmilitary coat. Later, in the 1950s, this style became extremely popular among students at schools and universities as well as with intellectuals as a practical, short coat.

Coat with cult status: the duffle coat.

Characteristic of the duffle coat are its box-like cut, the deep yoke on the back, the two patch pockets, toggle fastenings, and corded buttonholes as well as the large hood. Originally made of a thick wool fabric in the classic colors beige and blue, it now comes in a whole range of diverse materials and a fashionable palette of colors.

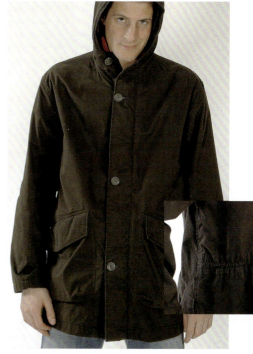

Borrowed from the Eskimos and loved around the world: the parka.

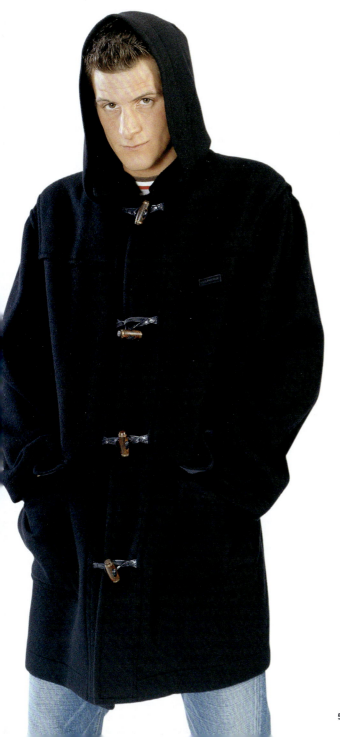

The Parka—The Coat from the Arctic

Like the anorak (see Chapter 5), the parka also comes from the Arctic. In the 1940s, the American military borrowed the basic form of the traditional jacket of the Inuit, transforming it into a camouflage green, thigh-length army jacket with drawstring, zipper, and large patch pockets. This item of clothing first became popular among young people during the 1970s. Today, the parka is regarded as a sporty all-purpose jacket in fashionable colors and trendy materials that can be worn with almost any outfit.

Parka and short Caban-style jacket from the 1970s.

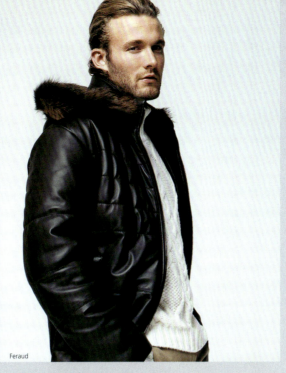

Feraud

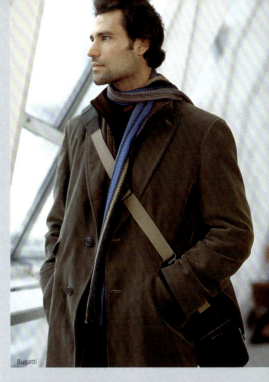

Bugatti

Pringle of Scotland

Marlboro Classics

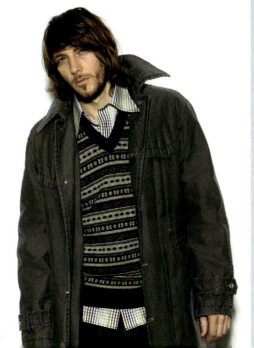

CINQUE

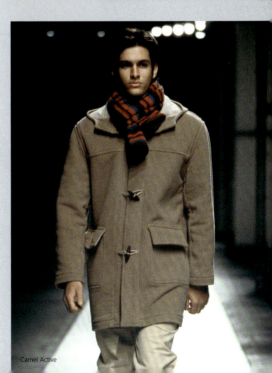

Camel Active

PANTS

Without spending a lot of time looking, finding the right pants with the right cut and fabric as well as in the right color and which are suitable for the season is a near impossibility! The variety of types, shapes, and cuts of pants has now become too vast to keep track of. The possibilities for mixing and matching them are just as varied, which sometimes makes it difficult to put together the perfect outfit. Pants have undergone dramatic developments during the course of their history. While men's legs were covered by stockings or tights for many centuries, these had little in common with today's leg wear for men. The 16th century saw the rise of knee-length padded breeches such as trunk hose or French hose, and unpadded breeches like slops and open crotch pants, that required huge amounts of material. In the 17th century, pants became more close fitting, like smallclothes, and plus-fours and culottes were also in fashion. These were worn as knee breeches ending above or below the knee. The knickerbocker was born in 1809 with the legendary *A History of New York* by Washington Irving (see Chapter 5). This style of pants first became popular for bicycling. The real forerunner of today's pants are pantaloons, which originated in the turmoil of the French Revolution. Since then, long pants have been the classic clothing for men's legs, even though the cut and style are continuously changing with various fashion trends. Short pants that came down to just above the ankles were popular in some eras, while pants with long legs that rested on the feet were popular in others. Wide pant legs experienced a fashion debut, just as did pants with legs which narrowed at the bottom. And at times, pants with extremely wide bell bottoms were an absolute must-have item. The crease and the turn-up cuff were added to pants in the early 20th century (see Chapter 2). Also worthy of mention is the pleat. From the 1930s onward, the zipper began increasingly to replace the button panel. Tight-fitting cuts began to appear from the 1950s onwards thanks to the influence of Italian designers. In the 1960s, clothing became more unconventional as a result of changing leisure-time behavior and a more athletic lifestyle. Young people had a strong influence and youth became the absolute fashion ideal. The suit, which had previously been considered the proper daily outfit, was now making way for single trousers along with sporty leisure-time suits and so-called mix-and-match outfits. Bell bottoms were the hallmark of the 1970s.

Men's gabardine from the 1950s with adjustable drawstring waist, piped and hip pockets, non-slip waistband, and lining at the knee. The pant leg turn-ups can be removed by unbuttoning them for convenient cleaning.

Various pant styles from the 1970s.

In the 1980s, pleats became fashionable once again and the 1990s saw the return of tight-fitting cuts. A diverse array of pant types have also developed until today. These include worker and cargo pants which were inspired by work clothing. They are not only used for work, however, but mixed and matched to form very sporty leisure-time outfits (see Chapter 5). The casual look currently calls for slim, figure-hugging cuts in the chino or flat-front style. Jeans naturally also fit well with this look. Some models now once again feature pleats.

Regardless of whether pants come with a crease or pleats, as bell bottoms or as pipe trousers, whether they have a tight-fitting silhouette or a wide cut, with the exception of extreme cuts that demand equally extreme wearing habits (such as the baggy trousers popular among teenagers), there are important details that a man should take into account for every pair of pants. Because only then do pants really look good. The circumference of stomach and

hips, the length of the legs, height of the waist, and width of the feet are all decisive in finding the perfect fit. Slim men can choose any waist height. The pants should fit comfortably and be neither too tight nor too

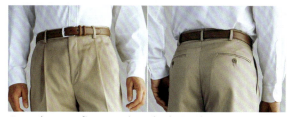

Pants have to fit properly to look good.

loose. Men with larger stomachs should wear the waistband across the stomach. Pants that stop below the stomach line only make the waist appear larger and they look sloppy as well. If in doubt, pant legs that are slightly too short are better than those that are too long. This holds especially true for smaller men, as shorter pants make the legs appear longer.

Coffee, Curry, and Mulberry Juice— Or How Khakis Got Their Name

Known as khakis, chinos, or Dockers, these warm-weather pants are equally sporty and elegant. They are the perfect choice when jeans are a little too casual and suit pants a little too formal. There are many stories about how they originated. They first became truly popular in the early 1980s, however. Paired with a blazer and deck shoes, they are a current favorites among American college students. Ralph Lauren copied the look and made it known worldwide. Levi Strauss then began marketing these internationally successful casual pants under the name "Dockers" in 1986. The style itself is much older, however. Their history goes back to the year 1848 in India, when the commander of an English regiment, Sir Harry

Chinos are an ideal partner for jackets, shirts, or T-shirts and take on an elegant or sporty appearance accordingly.

Lumsden, had the idea to dye the excessively white regiment pants of his soldiers in a mixture of coffee, curry, and mulberry juice to make them more practical for withstanding the dust that swirled everywhere in the region. The new color was accepted with enthusiasm, The Indians called it *khaki*, which means dust-colored or earth-colored in Hindi. The name chino was first introduced more than 70 years later. According to legend, the soldiers stationed in the Philippines were outfitted with these sturdy pants. Made in Manchester, the pants were sold to companies in China which in turn exported them to the Philippines. The Americans took the pants home with them and named them "chinos" because of their supposed origin. Whether chinos or khakis, a man can wear these pants on nearly every occasion and easily mix and match them with other items in his wardrobe. And by the way, Teddy Roosevelt is said to have worn khakis on his African safaris.

Jeans—No Signs of Age

Is there anyone who doesn't own a pair of jeans? In America, they have been regarded as affordable working pants since 1900. They first crossed the Atlantic to Europe with the landing of the Allies in 1944. Aided by Hollywood films, they were quick to become a fad there as well. They developed into a cult object for a rebellious youth and a source of trauma for a generation of parents in post-war Europe. The socially critical and successful novel *Die neuen Leiden des jungen W.* (*The New Sufferings of the Young W.*) by German author Ulrich Plenzdorf was published in 1973. In it, the protagonist Edgar Wibeau expresses his sense of connection with blue jeans: "Naturally jeans! Or can someone imagine a life without jeans? Jeans are the finest pants in the world … I mean jeans are an attitude and not a pair of pants." The immense popularity and the importance of jeans on the market attracted swarms of manufacturers to the scene, and even designers began paying attention to them. In the 1980s, jeans became part of the leisure-time look of well-to-do teenagers and young adults. The anti-establishment protest

No other pants are as much a part of the everyday outfit of every age group as jeans are. In addition to jeans in a wide array of colors, there are also shirts, jackets, and vests to suite every taste and style.

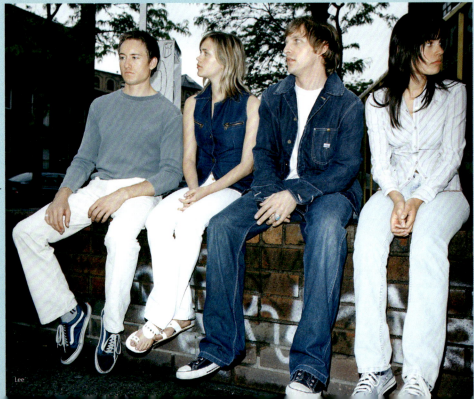

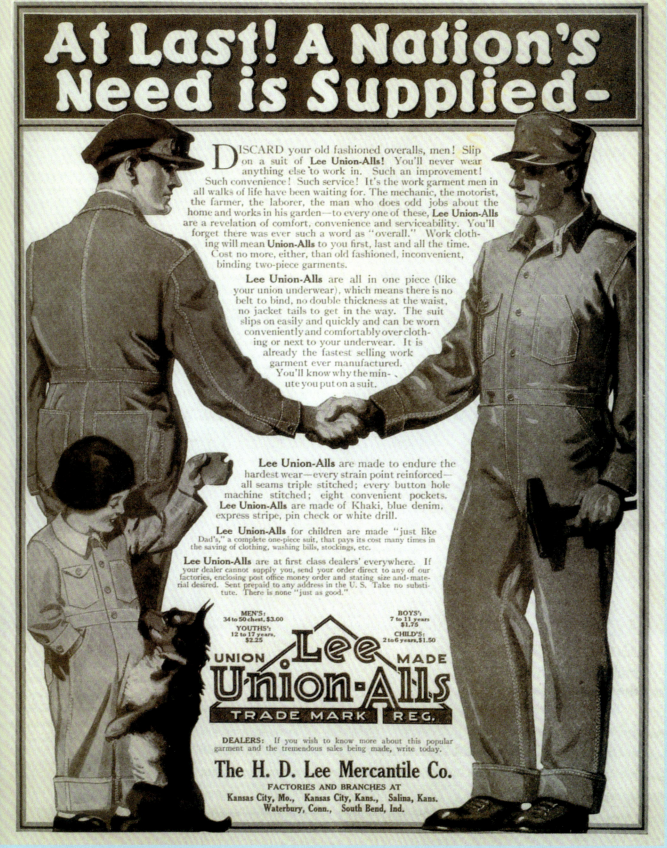

At Last! A Nation's Need is Supplied—

DISCARD your old fashioned overalls, men! Slip on a suit of **Lee Union-Alls!** You'll never wear anything else to work in. Such an improvement! Such convenience! Such service! It's the work garment men in all walks of life have been waiting for. The mechanic, the motorist, the farmer, the laborer, the man who does odd jobs about the home and works in his garden—to every one of these, **Lee Union-Alls** are a revelation of comfort, convenience and serviceability. You'll forget there was ever such a word as "overall." Work clothing will mean **Union-Alls** to you first, last and all the time. Cost no more, either, than old fashioned, inconvenient, binding two-piece garments.

Lee Union-Alls are all in one piece (like your union underwear), which means there is no belt to bind, no double thickness at the waist, no jacket tails to get in the way. The suit slips on easily and quickly and can be worn conveniently and comfortably over clothing or next to your underwear. It is already the fastest selling work garment ever manufactured. You'll know why the minute you put on a suit.

Lee Union-Alls are made to endure the hardest wear—every strain point reinforced—all seams triple stitched; every button hole machine stitched; eight convenient pockets. **Lee Union-Alls** are made of Khaki, blue denim, express stripe, pin check or white drill. **Lee Union-Alls** for children are made "just like Dad's," a complete one-piece suit, that pays its cost many times in the saving of clothing, washing bills, stockings, etc.

Lee Union-Alls are at first class dealers' everywhere. If your dealer cannot supply you, send your order direct to any of our factories, enclosing post office money order and stating size and material desired. Sent prepaid to any address in the U. S. Take no substitute. There is none "just as good."

MEN'S
34 to 50 chest, $3.00
YOUTHS'
12 to 17 years,
$2.25

BOYS':
7 to 11 years
$1.75

CHILD'S:
2 to 6 years, $1.50

UNION **Lee** MADE
Union-Alls
TRADE MARK REG.

DEALERS: If you wish to know more about this popular garment and the tremendous sales being made, write today.

The H. D. Lee Mercantile Co.

FACTORIES AND BRANCHES AT
Kansas City, Mo., Kansas City, Kans., Salina, Kans.
Waterbury, Conn., South Bend, Ind.

The first Lee advertising in 1927.

pants became recognized designer wear. Today, jeans belong to the everyday outfits of every age group and are part of the basic wardrobe in any closet.

When the inventor of jeans, Levi Strauss, emigrated from the small Franconian community of Buttenheim in Germany to America in 1847, he had no way of knowing that his future invention would become an ideology for many and a textile cult for entire generations. It was news of the discovery of gold on the West Coast of America that brought Levi to California. Once he arrived, Levi made robust working pants which could withstand the wear and tear of gold digging for the gold miners. As material, he used a blue-dyed, heavy-duty cotton fabric which had been produced in the city of Nîmes in Southern France since the Middle Ages and which was known as Serge de Nîmes in Europe. In American slang, this quickly was shortened to *denim*. The word jeans likewise originated in American slang. The gold diggers knew that similar pants, called genes, were worn by sailors from Genoa. This soon turned into the term *jeans*.

The only thing these pants were yet lacking on the way to becoming classic blue jeans were the metal rivets. As the pants' pockets didn't stay in place when rock

Levis 501

Levi Strauss is regarded as the grandfather of jeans.

samples were stored in them, the Polish immigrant Jakob W. Davis came up with the idea of securing these critical areas with copper rivets. He and Levi Strauss applied for a patent for these pants in 1873, the official birth date of blue jeans.

The original blue jeans have been augmented by a whole row of other models with a variety of cuts, materials, and details. Nor do blue jeans come in just blue anymore, but in the trendiest fashion colors of the current season. The fabric is turned into more than just pants, too. It has long since been used to make jeans jackets, shirts, coats, and vests. Jeans have meanwhile celebrated their 150th anniversary and are not showing any signs of aging. The former gold diggers' pants will remain a star on the fashion stage in the future as well, continually adapting to new markets and fashions.

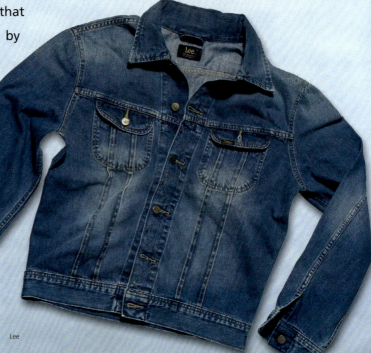

Lee

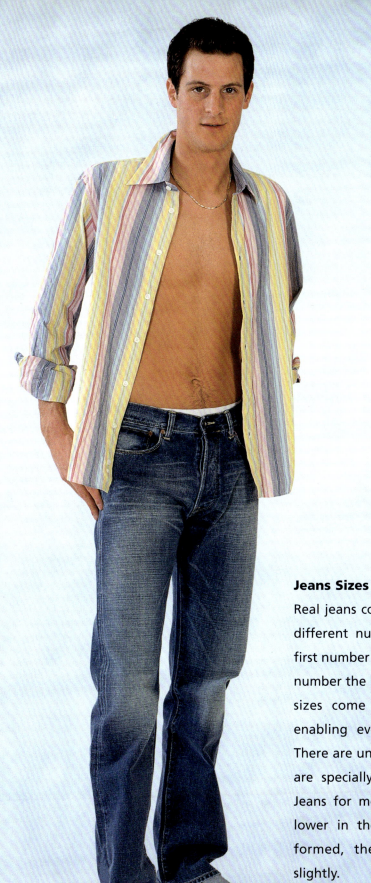

Jeans Sizes

Real jeans come in American inch sizes. Two different numbers appear on the tag. The first number shows the waist size, the second number the leg or inside leg length. The two sizes come in all possible combinations, enabling everyone to find jeans that fit. There are unisex models as well as jeans that are specially tailored for men or women. Jeans for men are higher in the back and lower in the front. The waistband is not formed, the waist and hips differ only slightly.

Waist size

In cm	70-72	72-74	75-77	77-79	80-82	82-84	85-88	89-92
In inch	28	29	30	31	32	33	34	36
size	40	42	44	46	46/48	48	50	52

Leg length

In cm	71	76	81	86	91
In inch	28	30	32	34	36
	short	relatively short	normal	relatively long	long

THE BUTTON-UP SHIRT

As an ideal mix-and-match partner for suits and sports coats or as a soloist with a pair of pants, the button-up shirt plays a key role for every man with style and taste. With a well-thought-out selection, a man can mix and match his wardrobe in manner appropriate to any occasion yet highly diverse. Only a few men can virtually do without button-up shirts. When it comes to casual shirts, almost everything is allowed—whether nonchalant elegance or sophisticated sport looks, with or without a

The button-down shirt with button-on collar points is less formal and looks good with a casual outfit.

collar, or worn over the waistband of the pants, this well-loved item of clothing is extremely flexible. Currently, fashionable shirt colors are cheery, soft, and fresh and come in lots of combinations. Checks and stripes are the most popular patterns for men. Many shirts lead a double life and can be worn equally well with a classic, formal suit or without a jacket when paired with jeans or khakis. One product of modern fashion is the breast pocket, which came onto the scene after the Second World War when men's vests began to disappear. This development meant it was no longer possible to carry practical utensils on one's person. The solution was a small breast pocket. Everyone knows at least one busy manager who always has a fountain pen in his breast pocket. According to true shirt "purists," however, a classic button-up shirt should not feature a breast pocket. A pocket should be found on casual shirts only. There are similar opinions in regard to the button-down collar. Its buttoned collar points give a shirt a less formal appearance.

The previous chapter discussed the history of the shirt, its development, and its importance. This chapter will cover the aspects a man should take into consideration when choosing a shirt. Even when some

The breast pocket is a product of modern fashion. Strictly speaking, it does not belong on a business shirt.

things may sound trivial, they can have a considerable impact on appearance. Despite perfectly fitting clothing, the head may somehow stick out awkwardly, thus giving a man a disharmonious overall appearance. This effect is often created by excessive differences in color. Men with reddish or pale skin, for

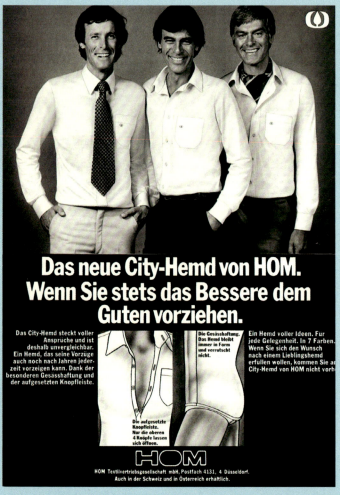

Hom advertising for city shirts in the 1970s.

example, do not look good in colors that are too dark or too bright. Somewhat lighter or less bright colors look better on them. Those with reddish skin should also avoid white, as white underscores red. In today's fashion world, age groups have been replaced by style groups. Fashion is dependent on style and taste, and is worn by all age groups. And that is how it should be. Nonetheless, shirts that are too youthful or too dismal can easily appear unkempt. This impression is also created when men with long necks wear their shirts open. A high-necked shirt or shirt with necktie can help here. You should also be careful of the transition from shirt to pants. Loosely fitting pants can exude a certain charm when worn on the perfect body. Those lacking a perfect figure, however, should make sure their shirts and pants fit perfectly, especially in the waist area.

Bright colors suitable for the wearer's skin tone, the right neckline, and accessories such as scarves ensure a youthful, well-groomed appearance.

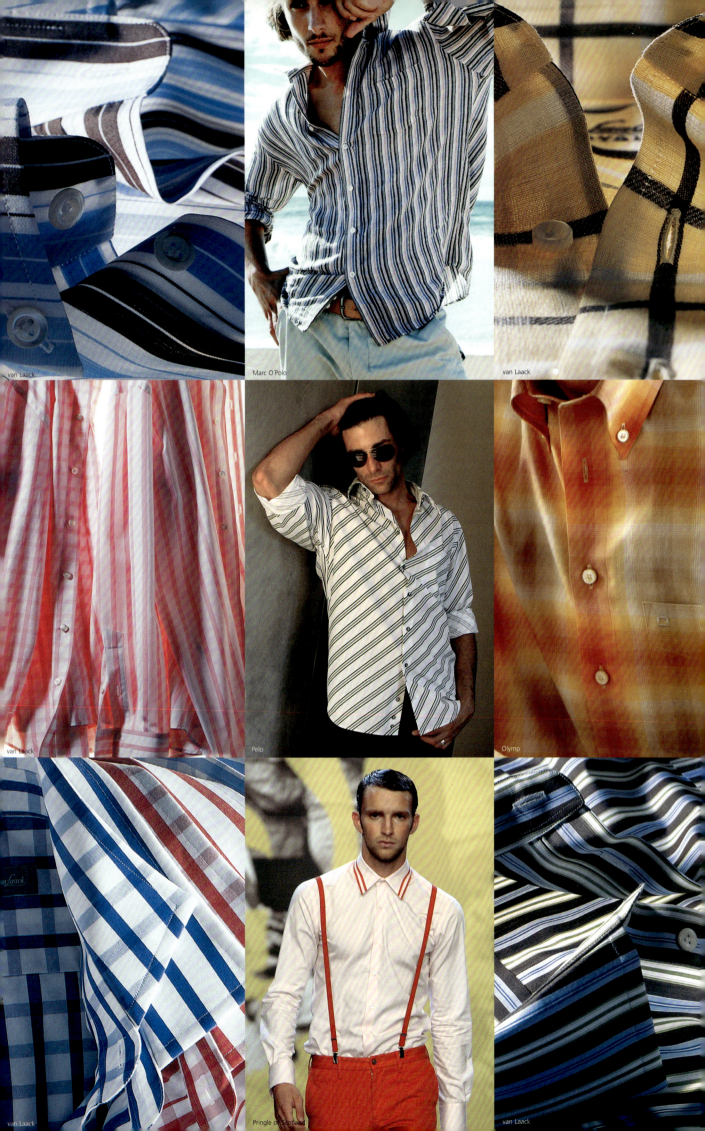

van Laack

Marc O'Polo

van Laack

van Laack

Pelo

Olymp

van Laack

Pringle of Scotland

van Laack

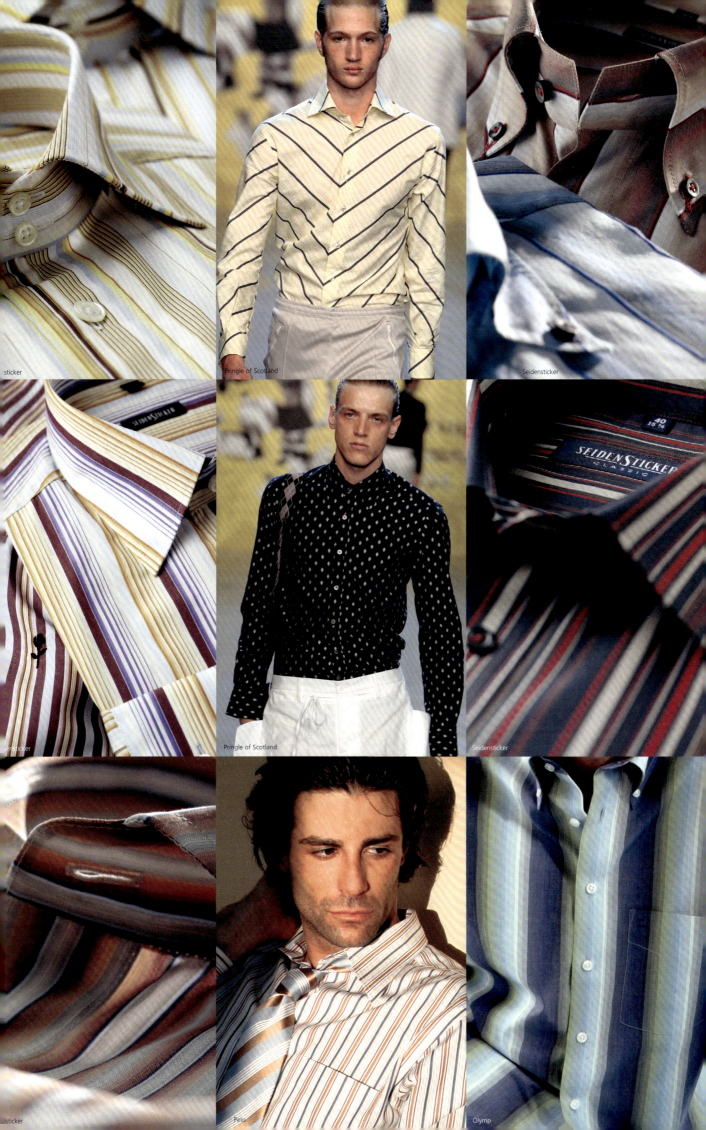

sticker

Pringle of Scotland

Seidensticker

ensticker

Pringle of Scotland

Seidensticker

sticker

Pelo

Olymp

Falke

Windsor

Pringle of Scotland

Men's Knitwear

Masculine coarse knits, fine or structured knits. Turtlenecks or polo collars, V-necks, rounded necklines, or zipper jackets. Solid colors, horizontal or vertical stripes, prints, applications or embroideries, diamond-shape patterns or Norwegian style—men's knitwear is innovative and highly versatile in cut, form, and color. In addition to wool, other fibers used include cotton, luxurious cashmere, and high-quality synthetic fibers, alone or in blends.

The knit garments worn by sailors were known as *jumpers*, they served as warm and elastic cloth-

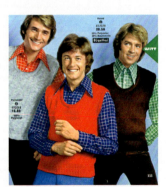

The 1970s: fashionably tight-fitting turtleneck sweaters, leisure-time shirt with typical print design, high collars with long points and sport cuffs and tank top with a low, rounded neckline.

ing for working in the rigging. This garment developed into the sweater in the late 19th century, and proved highly practical for sports such as horseback riding, golf, tennis, or bicycling.

After the First World War, the sweater increasingly began to appear in men's everyday wardrobes and was no longer reserved for sports alone. When a man wanted to appear especially sporty, he wore a sleeveless sweater instead of a suit vest. For a time, thin, finely knit turtleneck sweaters even replaced the shirt and tie in eveningwear. The style was made popular by artists such as Herbert von Karajan and Leonard Bernstein. This look was reserved for artistic circles only, however. Knitwear has still not advanced into the classic, formal men's fashion segment. Fine men's knitwear plays an important role in the urban casual segment, however. It is worn alone with pants or paired with a shirt and T-shirt.

sor

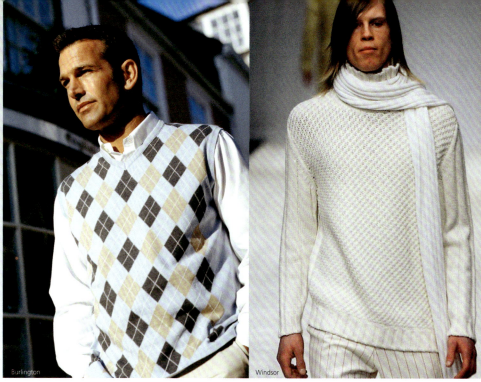

Burlington

Windsor

How the T-shirt Became Fashionable

As legend has it, we own the T-shirt in its classic form to Queen Victoria of England. In order to ensure that the queen would not be confronted with the sailors' armpit hair during an inspection of the navy in 1890, the captain had short sleeves sewn onto the sailors' undershirts. In the following years, the short-sleeve shirt with a buttonless neckline sitting below the chin became popular as fashionable underwear and practical sports clothing.

The plain, white undershirt became an international fashion item in the 1950s. In the Hollywood movie *A Streetcar Named Desire* (1951), Marlon Brando aided the T-shirt to a fashion breakthrough in the role of the down-and-out drinker Stanley Kowalski, his muscular upper body packaged in a tight-fitting T-shirt. As an ideal complement to jeans, the T-shirt became the outfit of a young generation seeking freedom. The T-shirt is meanwhile socially acceptable, a global outfit for both young and old. More than two billion T-shirts are sold each year.

Of course there are occasions when a T-shirt would be in somewhat questionable taste and there are items of clothing it does not suit. In principle, however, designer Helmut Lang was right when he said: "The T-shirt is the only piece of clothing that submits fully to our wishes. Sometimes underwear, sometimes outerwear, it changes with customs and seasons." Manufacturers and fashion designers are always finding new ways to vary this piece of clothing which has remained unparalleled until today. In addition to the classic form, there are also models with different sleeve and neck cuts, with a button-up breast panel or breast pocket. Men are no longer limited to conventional cotton when it comes to choice of fabric either. An especially innovative creation of the 1990s was the tattoo shirt by French designer Jean-Paul Gaultier, featuring all-over prints on see-through, stretchable fabrics which created the appearance of body painting. The idea of printing the T-shirt and turning it into a communication medium was hit upon in the 1970s at the latest. The white surfaces without disruptive button panels or seams were ideally suited for declarations, slogans, and political statements.

"I ♥ N Y" from Milton Glaser has been printed on millions of T-shirts. Che Guevara and the Rolling Stones emblem—John Pasch's tongue—were long-term bestselling motifs. The punk shirts from Vivienne Westwood are also famous. When Margaret Thatcher met with British designer Katherine Hamnett in 1984, Hamnett wore a T-shirt printed with

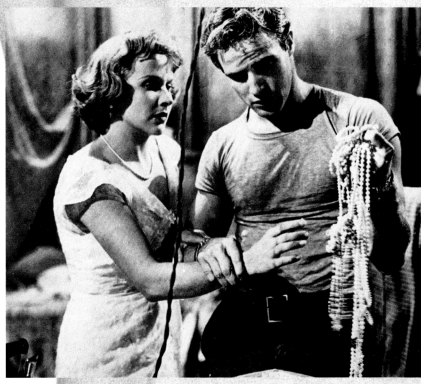

Marlon Brando as Stanley Kowalski in the 1951 Hollywood movie A Streetcar Named Desire.

T-shirts that have attained cult status: Che Guevara and Hard Rock Cafè.

the words "58% don't want pershing." Anything and everything is printed on T-shirts. Fan and concert T-shirts, souvenir shirts or so-called art shirts are popular. Companies give away T-shirts with their name on them, cities use them to display previously unknown local patriotism, and even designers print their label on the simple piece of clothing. Coca-Cola is turned into Co-Caine, Marlboro into Marijuana, or you can invent a personal creation with the help of a T-shirt painter. The possibilities are endless. The white T-shirt was and is a classic, however, along with black and gray. The T-shirt will always have an established place in the closet, because you can wear it with simply every other garment.

The Polo Shirt

The polo shirt is a good alternative. You feel as well-dressed as in a button-up shirt, but as casual as in a T-shirt. The English imported this popular piece of clothing, together with the sport of polo, from India in the late 19th century. Réné Lacoste made the polo shirt popular around the world. The French tennis star of the 1920s had a sports shirt made just for him which was designed to look like the shirts of polo players: it could be pulled on and had a soft, flat collar and button panel. Later, as a textile merchant, Lacoste initially made his shirt with the crocodile emblem popular as sportswear. The shirt became a part of leisure-time fashion in the 1960s and a status symbol in the 1980s. Sweaters with a polo collar are popular as a wintertime version of the polo shirt. The polo shirt can also be paired with a sweater, but should be worn without a necktie.

Lee

The polo shirt is an alternative to button-up shirt and T-shirt. The typical collar shape can also be found on sweaters, which fashion-conscious men like to wear with a shirt.

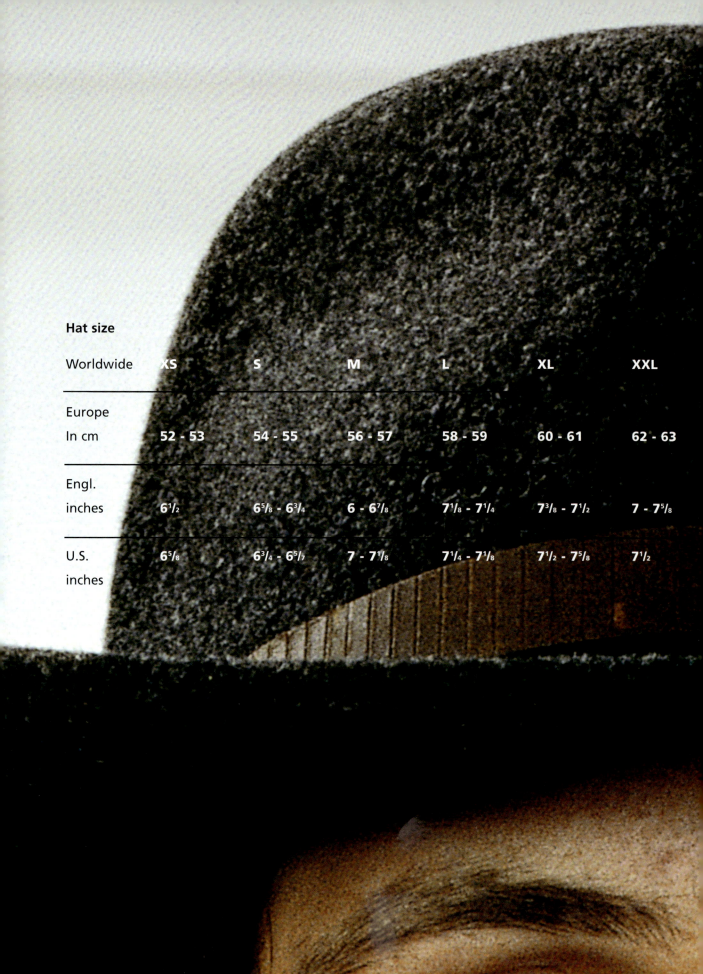

Hat size

Worldwide	XS	S	M	L	XL	XXL
Europe In cm	52 - 53	54 - 55	56 - 57	58 - 59	60 - 61	62 - 63
Engl. inches	$6^1/_2$	$6^5/_8$ - $6^3/_4$	6 - $6^7/_8$	$7^1/_8$ - $7^1/_4$	$7^3/_8$ - $7^1/_2$	7 - $7^5/_8$
U.S. inches	$6^5/_8$	$6^3/_4$ - $6^5/_7$	7 - $7^1/_8$	$7^1/_4$ - $7^1/_8$	$7^1/_2$ - $7^5/_8$	$7^1/_2$

FASHIONABLE
HEADGEAR

FASHIONABLE HEADGEAR

Now that caps have become a standard part of the fashion landscape, hats are also in demand once again. They are worn with elegant, casual outfits, although the design of the decorative head coverings is a copy of famous classic styles. One example is the Panama hat, which should really be called the Ecuador hat. For centuries, it has been made by hand there from of the leaves of the *Toquilla palm* in a process requiring great

Spencer Tracy in the film version of the successful novel The Old Man and the Sea *by Ernest Hemmingway.*

manual dexterity. An Ecuadorian hat maker requires eight hours for the weaving alone. The Panama hat gets its typical color and shape during subsequent bleaching, drying, and pressing. It is very flexible and can be easily rolled together and folded. The stylish hat became popular during the construction of the Panama Canal connecting the Atlantic and the Pacific across the isthmus of Panama

and opened in August 1914. The trip through the canal, which is 81 kilometers (50 miles) long and up to 300 meters (984 feet) wide, takes seven to eight hours. North Americans and Europeans were equally taken with the light, airy, and airtight hat of the Ecuadorian Indians. It has been spotted on famous heads such as those of Impressionist Max Liebermann, author Ernest Hemingway, and politician Winston Churchill.

Ornamentation, protection, and identification—these have been the purposes of headgear since ancient Egypt. In the Middle Ages, when the hat became an established part of the wardrobe, every social class had a specific type of head covering. Examples include kings' crowns or the miter of the church dignitaries. Many types of hat shapes developed over the course of the centuries. In addition to the Panama hat, well-known styles include the top hat (see Chapter 6), the Stetson, the trilby, the homburg, the bowler hat, and the Borsalino. Although they used to be common sights on every street corner, many of them are no longer seen at all. Some are still holding their own in special niches or become fashionable again from time to time.

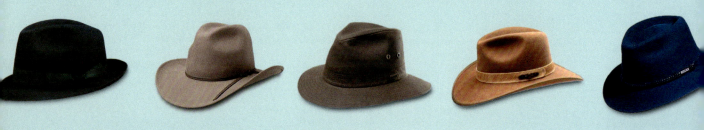

"Stetson, it's not just a hat, it's the hat," was the slogan of the Stetson Company from Missouri, makers of one of the most well known hats in the world. In 1865, with 110 dollars for material, equipment and premises, the hat maker John B. Stetson laid the foundation stone for the most successful hat factory in America. It would go on to produce hundreds of different styles. Among the first was the *Hat of the West*, also known as *Boss of the Plain*, which is still one of the classic Stetson products. It is the world-famous cowboy hat with a broad brim that protects against the sun and functions as a water gutter. The form of the cowboy hat can in turn be traced to the Spanish sombrero (from the Spanish word *sombra* = shade). A hat always consists of a headpiece and a border and is made of fabric, fibers, or felt. Felt is an ancient technique passed down from nomadic peoples. Rabbit, hare, or beaver fur is used in felt production. Between 100 and 200 grams of fur are needed for one hat. This is equivalent to approximately three animal skins. High-quality felt hats have a silky surface and are considered indestructible.

Another classic among felt hats is the Borsalino. Like the Stetson, it is not a type of hat but a brand. It is named for the Italian hat maker Giuseppe Borsalino, who founded a hat factory in Milan in 1857. The factory still produces a very large selection of hats. More than 4,000 exhibits can be viewed in a hat museum there. The Borsalino is familiar as a part of the clothing of film greats like Alan Delon and Jean-Paul Belmondo.

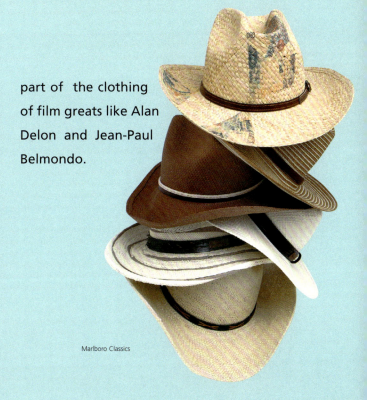

Marlboro Classics

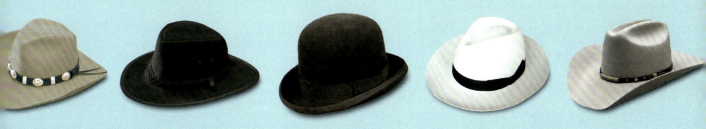

SOCK STORIES

The sock has a long history behind it. Archeological finds have turned up leather and fabric rags, wrapped around the leg to the knee, which the Kelts and ancient Germans referred to as *huson* or *hosa*. These garments were used until well into the 16th century. During the age of the Byzantine Empire, it was common for members of the upper class to wear colorful, printed half stockings made of brocade or silk. Stockings for men were developed around 1500, inspired by coats that barely reached the hips. Stockings or tights in many different colorful combinations were popular. The aristocracy wore hand-knitted stockings that were considered a symbol of wealth, power, and luxury. Henry VIII, for example, loved knitted silk stockings and is considered one of the first to wear them.

Hand-knitted pontifical sock from the 11th century.

The English priest William Lee built the first mechanical stocking knitting machine in 1589. The occupation of the stocking knitter became an established trade subject to guild rules. The first circular knitting machines appeared in the late 18th century, making possible the production of seamless tubes. With the advent of long pants in the

19th century, stockings became shorter and were worn up to the calf. The so-called sock was held up with a ribbed, knitted band or with sock holders—a band positioned above the calf. Later, rubber bands were also used. In 1868, the English design engineer William Cotton developed the Cotton Machine, which was named after him and could produce up to 40 sock parts per work cycle. The advent of socks brought with it the demise of tights in men's fashion. Socks with creative patterns such as horizontal or vertical stripes and checks became popular.

Selecting socks is primarily a matter of personal taste. Color and style should naturally match the outerwear and not dominate the outfit. Men who feel uncertain about wearing patterned socks should stick with solid colors. If you do wear patterns, the dominant color in the pattern should be matched with that of the T-shirt, button-up shirt, or sweater.

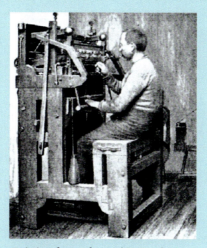

Knitting frame for making socks in the 18th century. The socks made on such machines had little in common with today's fine knitwear.

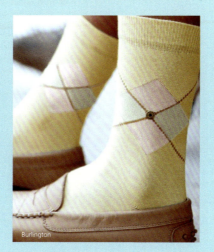

Knitwear production on manual flat bed knitting machines circa 1925.

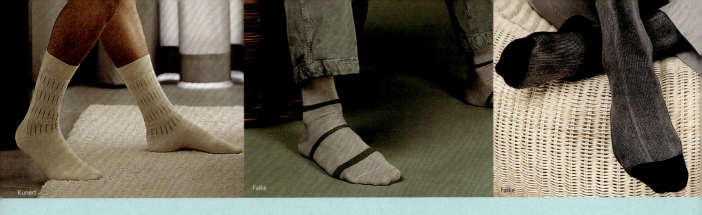

Kunert Falke Falke

OF SLIPPERS, LACE-UPS, AND BOOTS

The basic shoe shapes, from which manufacturers and designers develop many different variants, were described in the previous chapter. Several factors play a role in the type of shoes a man wears. Shoes should match the overall outfit and occasion. The more formal the outfit, the less suitable are casual shoes. Besides this, shoes should underscore the individual personality of their wearer. In the casual sector, it is fairly easy to find personal favorites. The perfect shoes for every outfit and every style can be found in the range of available models – whether a chic soft loafer or a sleek city slip-on, a classic lace-up shoe such as the Brogue, or cowboy boots. The latter already make clear that men's fashion is currently once again drawing inspiration from Western elements. And what would the modern asphalt cowboy be without boots? As this type of footwear has always been controversial, it is a good idea to take a closer look at the origins and history of these trendy boots.

Charles H. Hyer and His Shoes

Today we look back fondly on the North American cowboys who drove their herds of cattle through the heart of the prairies to the meat markets of the Mid West more than 150 years ago. These men were impressive riders, marksmen, and pathfinders. Most of them were former soldiers of the confederated armies, searching for a new way to earn a living after the Civil War. Their boots from the Civil War were not suitable for the new job as they were too wide in the front and had a flat heel. The search for new ideas began. According to one story, these ideas materialized in the form of a shoemaker from Kansas and his brother – Charles H. and Edward Hyer, sons of a German immigrant who ran a shoemaking business. One day, an unknown cowboy is said to have asked the Hyers to make boots in a previously unheard-of form: pointed in the front so that one could slide quickly into the stirrups, a higher slanted heel so as to help keep the foot in the stirrup, and a high shaft with a shell top. Charles Hyer liked the new shape. He began making more boots of this type and they were soon an established form. The Hyer brand became extremely well known. Buffalo Bill, Teddy Roosevelt, and Dwight Eisenhower are said to have worn Hyer boots.

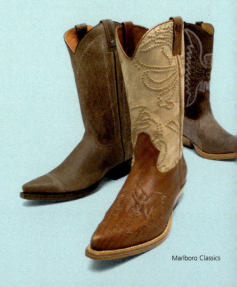

Marlboro Classics

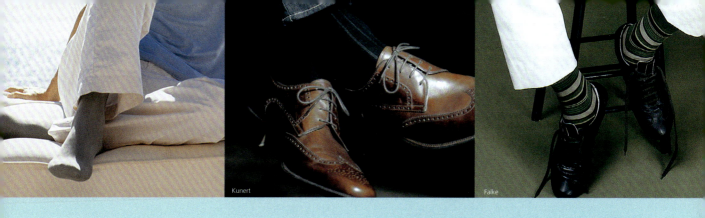
Kunert Falke

Moccasins and Loafers – Comfortable and Lightweight

Embroidered with colored porcupine quills and decorated with leather fringe—that is how we have always seen this slip-on shoe as the original footwear of the North American Indians and Canadian hunters in legendary films. In the 1930s, a slightly altered form of the moccasin became popular as a sports shoe for men. The Italians in particular produced true masterpieces.

The loafer from Gucci with the horseshoe-shaped, gold-plated clasps as a reference to the sport of horseback riding and the founder of the Gucci company, the saddlery maker Guccio Gucci, became world famous and advanced to a timeless classics. Today, the moccasin, or loafer, is considered an all-purpose shoe that works well with both suits and smart city looks.

The Brogue

The Brogue, with its typical decorative perforations, is one of the well-established men's street shoes. These shoes are also known as Budapest shoes because of Hungary's reputation for high-quality shoes. Originally, however, it was a simple, practical Irish farmers' shoe designed to provide the foot with optimal protection. This was also the reason for the perforation holes, which were intended as drain holes for any water which may have collected in the shoe while walking in the damp Irish landscape. Later, it proved an ideal shoe for English hunters and gamekeepers and then an elegant sports shoe for golf. In the late 1920s it was made popular by dandies, and has proved itself an excellent city and leisure-time shoe until today.

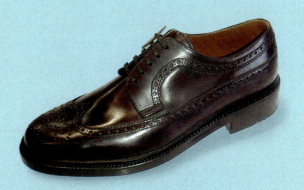

Conley's

Bäumler

Marlboro Classics

Strenesse Gabriele Strehle

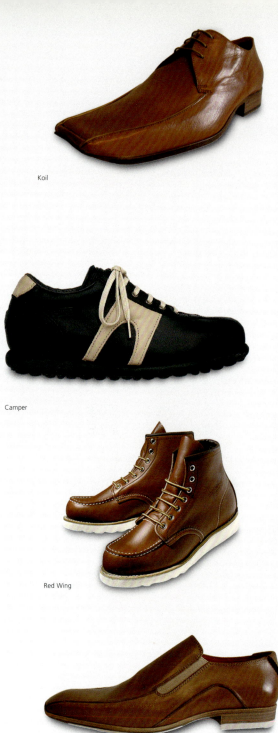

Koil

Camper

Red Wing

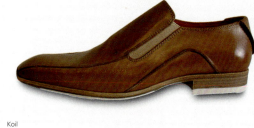

Koil

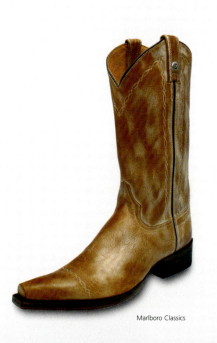

Marlboro Classics

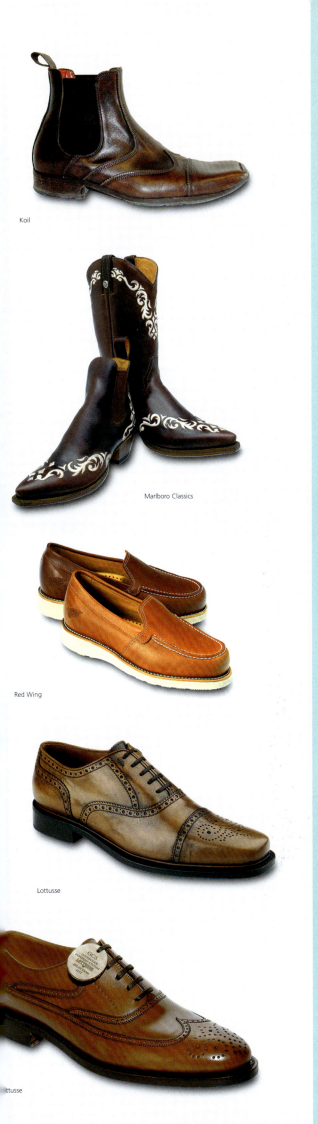

Koil

Marlboro Classics

Red Wing

Lottusse

ttusse

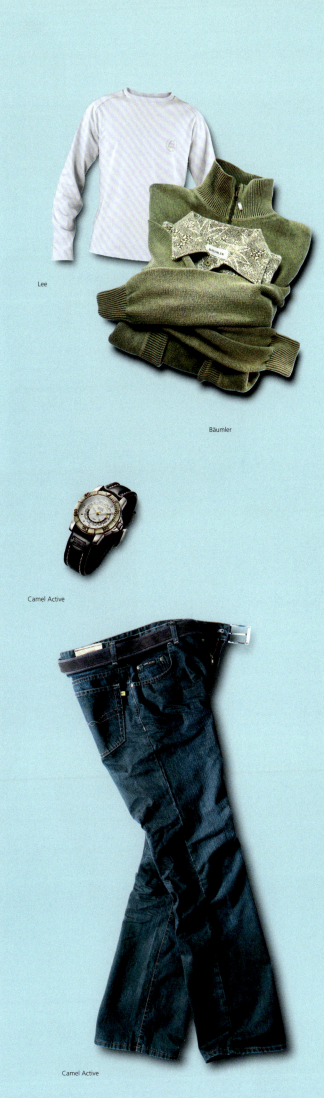

Lee

Bäumler

Camel Active

Camel Active

FASHIONABLE AND FIT

Sports have gained steadily in importance over the course of the last few decades. Regardless of whether enjoyed on TV or in person—sports play an important role in most people's lives. Fitness and feeling good about their bodies have become a part of quality of life for an increasing number of people. Yet it is about more than just athletic ambition. Moving freely in nature, the feeling of belonging to a group, and taking pleasure in the activity itself turn sports into a true delight. Clothing that is both functional and practical as well as in keeping with current fashion trends and style rules is essential.

GOLFING ALL OVER THE WORLD

Whether on the beaches of Guadeloupe or California, on the Bermudas, in South Africa, or in the desert of Dubai. Whether ski golfing in America or ice golfing in the Alps or Scandinavia. Golfers indulge in their hobby everywhere, on so-called golf & cruise tours on shipboard, on faraway greens, or by setting sail for golf courses located on the world's most beautiful coasts with a Windjammer. Golf is an immensely popular sport. There are more than 12,000 golf courses in the U.S.A. alone, on which over 20 million golfers play annually.

The image of golf as an old-fashioned activity for rich retirees has changed. Golf has become a general leisure-time pleasure for a new, young generation of golfers. Top athletes such as Tiger Woods have given the sport important momentum. It is more suitable than any other sport for people of every age and physical condition. Yet the combination of flexibility, concentration, and stamina which it demands are challenges for any sport enthusiast.

Golf was invented more than 500 years ago on the British Isles. The first golf clubs outside of Great Britain were founded, characteristically, in India; in 1829 in Calcutta and 1842 in Bombay. Golf first became an Olympic sport

Tailor-made golf shoes by Hubert Gassenschmidt from Baden-Baden.

Every golfer dreams of playing in Dubai. Pictured is the club house of the Emirates Golf Club (18th hole).

in 1900. The oldest and most famous golf course in the world is St. Andrews' Old Course in Scotland. Every golfer dreams of playing there one day. This is the home of the Royal and Ancient Golf Club, the rules of which are authoritative for the game of golf all over the world. One should do more than just know the rules of the game in golf, however. Most courses also have a certain dress code. Jeans, T-shirts, and trunks are not welcomed on the golf course. A man is always appropriately dressed in a polo shirt, i.e. a shirt with a collar, long or short golf pants, and golf shoes equipped with small spikes. The outfit is completed with a cap and gloves to prevent blisters on the hands.

By the way, the most expensive club in the world was bought by an American dealer in 1991 at an auction at Christie's. The price? Approx. $ 5 million dollar. The club was made in the 17th century and was found in a hedge near the North Berwick Golf Club, in Scotland.

Shoe-making technology from the 19th century.

WINTER SPORTS

The last summer vacation has hardly past and the first signs of winter just begin to appear, when every winter athlete will start to feel restless. The leg muscles are brought into tip-top shape, sports outfits and equipment are updated. Dreams of endless ski trails, grandiose mountains under blue skies, lots of snow, and non-stop fun—that is the fascinating attraction of skiing.

More than a thousand years ago, inhabitants of the snowy parts of the earth were already strapping a type of skies to their feet. With two wooden boards under their feet and a pole for helping keep their balance, they could move easier through heavy snow. The Norwegians are thought to be the ones who invented these *snow shoes*. And it is in Norway that the sport of skiing likely has it origins. According to history, the first alpine ski contest took place in Oslo in 1850. Soon thereafter, the first skier was spotted in St. Moritz. The conquering of the Alps by the white sport had begun. The first Olympic Winter Games took place at the foot of Mont Blanc in Charmonix, France, in 1924. Medals were awarded in the Nordic Combination, cross-country skiing and ski jumping, speed skating, figure skating, bobsledding, and ice hockey. Alpine skiing was first introduced to the Olympic program during the Olympic Game in Garmisch Partenkirchen in 1936. The sport in the snow is one of the most well-loved and popular sports in the world. Carving, freeriding or snowboarding, mono-skiing or snowblading, ski hiking or heliski-ing. In Canada, the U.S.A., in Europe, and Japan—the sport of skiing was never as varied as it is today.

In the early days of skiing, men wore knicker-bockers with puttees and knit vests, while women skied in long skirts. The bar has meanwhile been raised in terms of clothing. Winter athletes are now demanding clothing that is suitable for a wide variety of weather conditions and activities. And it should be functional and highly fashionable while offering optimum protection and high wearing comfort. Breathing fabrics ensure that excess moisture and heat are channeled to the outside of the clothing as quickly as possible. This clothing must be wind- and water-proof and have welded seams. What's underneath must be perfect as well. This includes good, functional sports underwear. A cap and scarf aren't just accessories that complete the outfit, they ensure that the head stays warm as well. The German Willy Bogner and the Norwegian Helly Hansen have played a pioneering role in turning simple ski clothing into innovative outdoor clothing. Captain Helly Juell Hansen already developed water- and windproof work clothing for his crew back in 1877. The secret: linseed oil. During the 20th century, the traditional Helly Hansen company introduced numerous innovations for outdoor sports on water, on land, and in the snow to the market.

Bild.

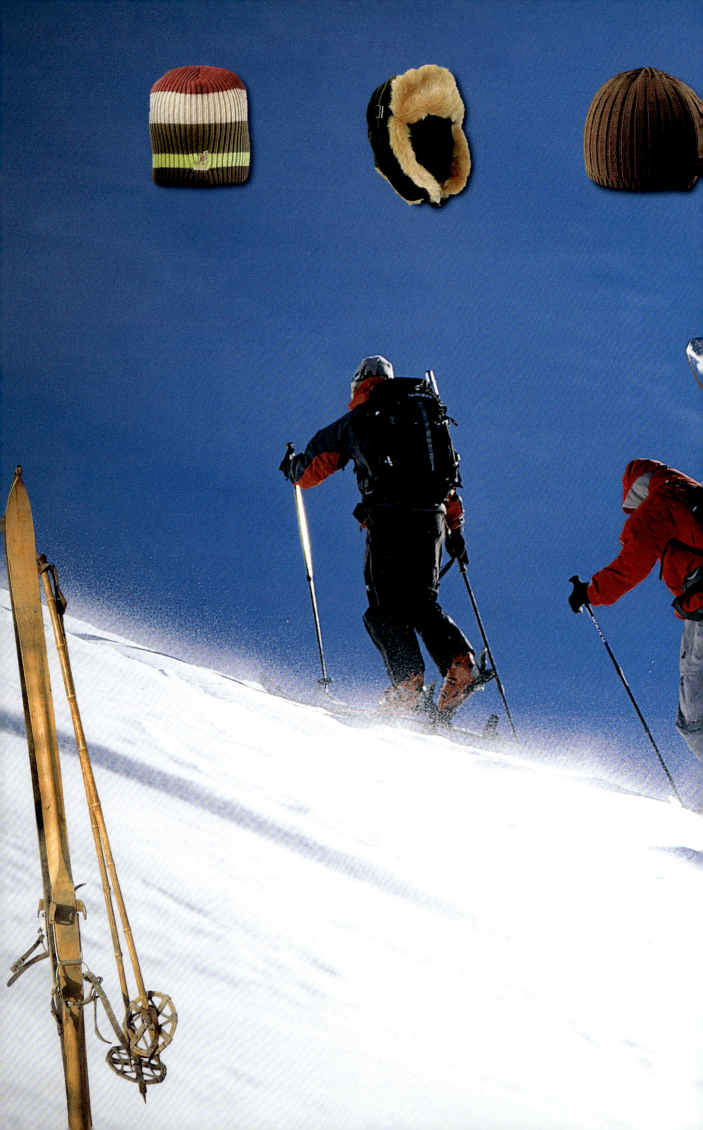

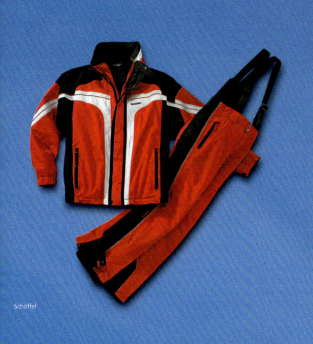

Schöffel

Ski clothing from different eras. In the 1960s, men wore stretch pants and a quilted anorak with two-way zipper, belt, zipper pockets, knitted wristbands, and hidden hood. Harem pants became popular in the 1970s. Today's ski outfits meet every conceivable demand in terms of equipment, function, and design.

Schöffel

Schöffel

Schöffel

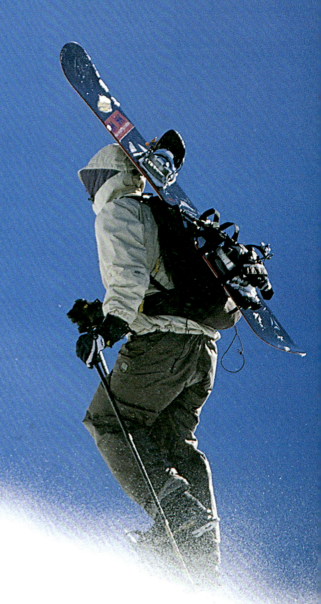

Bild:

GET IN SHAPE

In the early 1970s, an idea from Finland unleashed a true wave of enthusiasm in Germany. This was when the Deutsche Sportbund (German national sports league)

Trimmy and his thumbs-up sign encouraged the Germans to exercise more.

launched the large-scale exercise campaign *Get in shape with sports!* The reason behind this move was the gradual appearance of illnesses associated with prosperity, such as heart attacks and excessive fat. Every city installed a fitness trail. A square-headed figure called "Trimmy" giving the thumbs' up sign on countless posters encouraged the sedentary Germans to exercise more. Through the woods at a run, stopping at stations to perform push-ups on wooden platforms, pull-ups or balance acts on wooden bars. Small blue signs explained what was to be done at the stations. The campaign was a great success. By the mid-1970s, more than 70% of the population was physically active.

Today's clothing for sports enthusiasts is marked by innovative textile solutions that meet even the highest demands on functionality and quality. A model from Asics is pictured here.

Being "on the run" is trendy. Running is now a mass sport!

Today, 30 years later, fitness trails have faded from fashion, but the Germans are still active. And not just the Germans either. Jogging is the most popular sport worldwide. In woods, over fields, or in city parks—people of every age and fitness level are running for all they are worth. And with sufficient training they may be able to take part in one of the innumerable city marathons. Those who aren't quite ready for that level of fitness can try Nordic Walking. The well-informed man of today knows what healthy exercise is. Running for 20 to 30 minutes in the fresh air on a regular basis promotes inner balance, helps reduce stress hormone levels as well as strengthening the heart and the immune system. Regardless if summer or winter, rain or snow, sport in the great outdoors is always a good idea—when you are wearing the right outfit.

SPORTS SOCKS

For centuries, tights were the main item of clothing for men's legs. This changed with the advent of longer pants. The stocking industry reorganized its production and began concentrating on socks and knee socks for men. More men's tights were produced after the Second World War, toted as the ideal foundation for leisure-time and sport activities such as motorcycling, camping in cooler climates, or winter sports. Manufacturers developed special ski tights, for example, with knitted terry cloth feet. Tights for ice hockey were made to be especially elastic so that shin and knee protectors could be worn under them.

THE IN-SHOE REVOLUTION

FALKE
ERGONOMIC SPORT SYSTEM

Athletes wear socks that adapt to the needs of their particular sport.

There were also special tights for cross-country skiing. These proved equally suitable for other sports and leisure-time activities for which knickerbockers were worn. Men's tights currently have tough competition from modern underwear or functional wear. Special socks for particular sports are always in demand. When playing sports, men wear socks made of innovative materials that are individually adapted to the right and left foot as well as to the specific type of sport.

POWER

& FALKE

Wolford
Herren
Strumpf
Hose

Tights for men are the ideal addition to business or leisure-time clothing in cold climates.

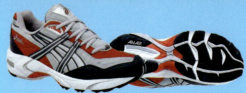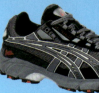

Modern running shoes are designed with attention to every detail and lots of technical expertise. There are individual solutions for every runner in terms of stability, damping, lightness, movement control, and trail. Models from Asics.

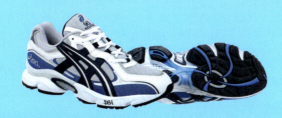
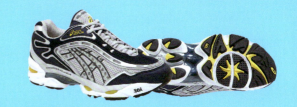

FROM LEATHER BOOTS TO MODERN RUNNING SHOES

Can you image wearing a pair of ankle-high boots outfitted with leather-covered studs and leather-reinforced front caps and weighing 500 grams even when dry? These were the kinds of shoes used for playing rugby, soccer, and croquet in the late 19th century. The modern soccer shoe is streamline-shaped, equipped with plastic soles and screw-in studs, and weighs less than 250 grams. Today such standards are a matter of course. The first shoe made especially for sports was produced by the American Wait Webster (see also Chapter 5) and the British New Liverpool Rubber Company. Completely independent of one another, the two developed linen

Modern soccer shoes with screw-in studs.

shoes with rubber soles that could be worn for croquet and tennis as well as on the beach. The father of the modern sports shoe was Adolf "Adi" Dassler, who began producing sports shoes around 1920. The product portfolio was soon expanded to include soccer shoes with studs and running shoes with spikes. In 1936, Adi's shoes were regarded as the best in the world and worn by top-class athletes such as the four-time Olympic winner Jesse Owens. Today's running shoes, with the upper part made of mesh fabric and super-lightweight soles, can weigh less than 100 grams. The use of plastics in the production of sports shoes permits fashionable design while simultaneously providing optimal protection and comfort. The switch to plastics also revolutionized other sports. A good example is the ski shoe. 30 years ago, no skier could have imagined the typical bindings and shoes of today.

Modern ski boots.

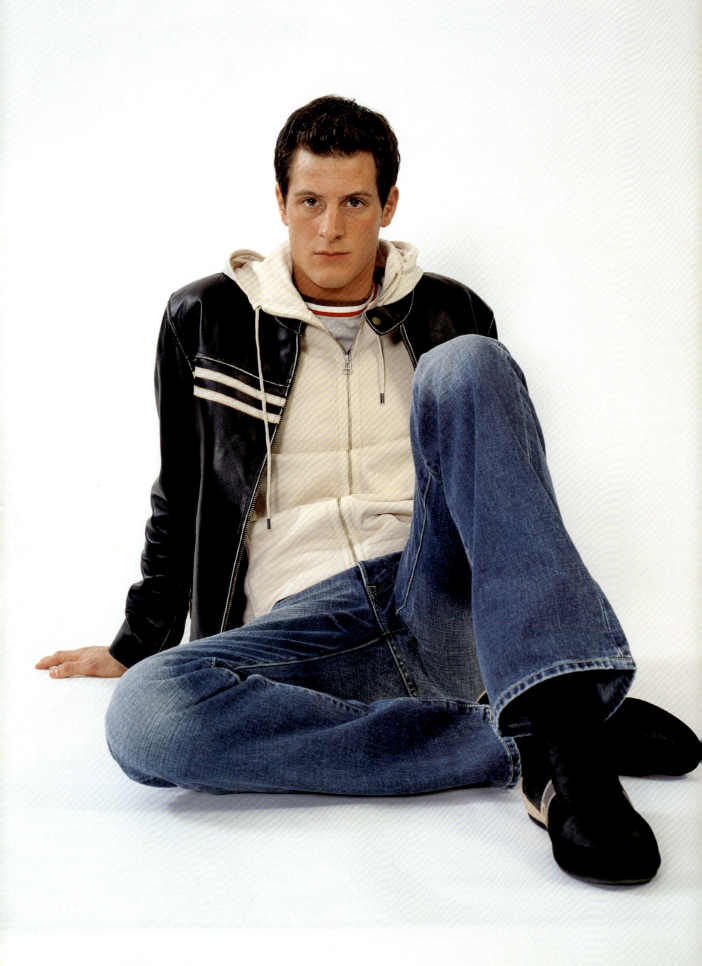

ACTIVE SPORTSMEN

5

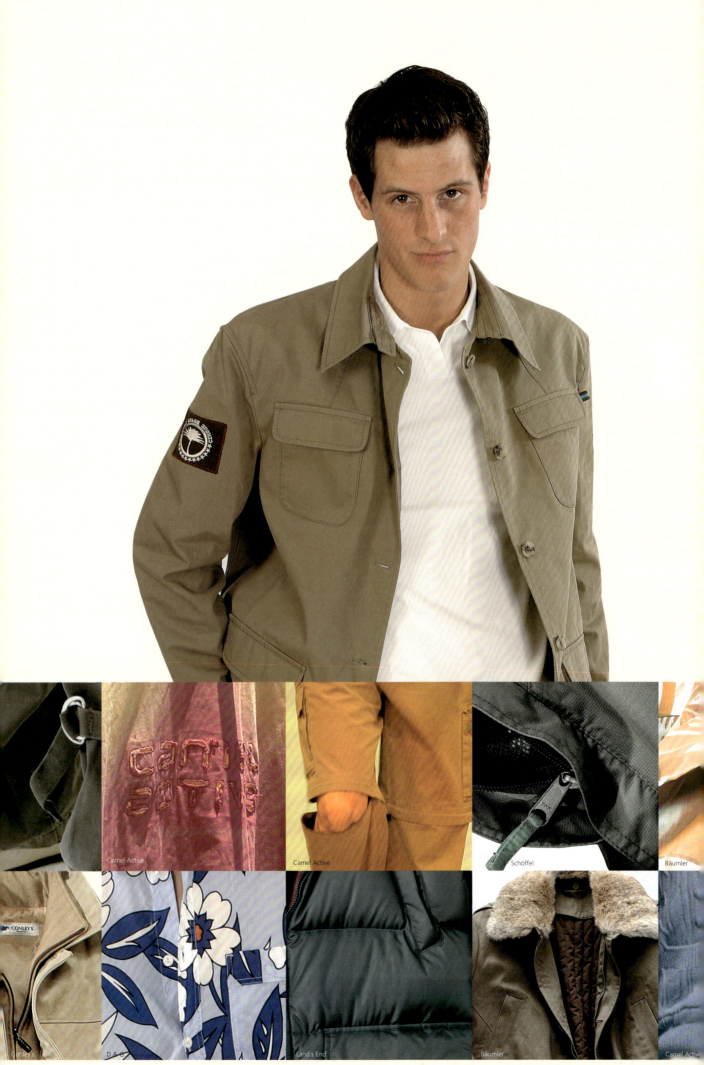

Camel Active

Camel Active

Schöffel

Bäumler

Conley's

D & G

Land's End

Bäumler

Camel Active

SPORTY LEISURE-TIME FASHION

In addition to the formal, proper business suit and the casual or city look, the sporty and relaxed leisure-time outfit is beginning to play an increasingly important role in fashion. For a trip to the beach, a drink in the nearest pub, or a short jaunt to the country, you can't go wrong in a sporty look with an active touch. Sportiveness means flexibility, a positive attitude towards life, mobility. It embodies values that are top priority for our modern society. The fit of clothing ranges from tight to loose, details are important, function is the key word: pocket variants, movement folds, quilting, draw strings, zippers, knit, fabric blends, lots of patterns, decorative prints, and embroidery. A man can thus present himself entirely in a casual manner yet well-groomed and in high-quality style. The cuts and shapes are often not new—like everywhere in fashion, elements are being picked up that have long since been tried and tested.

One example is the blouson, which is experiencing a fashion comeback in altered form. It is worn in the campus look, with quilted seams and zippers, or in a tougher look as a bomber jacket with contrasting trimmings and knit wristbands. As an alternative to the blouson, men wear field jackets, a new term for jackets in the colonial style. When it comes to warm jackets for the cold seasons of the year, the tone is set by high-quality, weatherproof fabrics, two-in-one effects, detachable quilted vests, inner linings made of fur, wool, or fleece, knit collars, or caps. Men like it sporty, men like it casual, and men like it functional. Functional jackets are no longer reserved for sports alone.

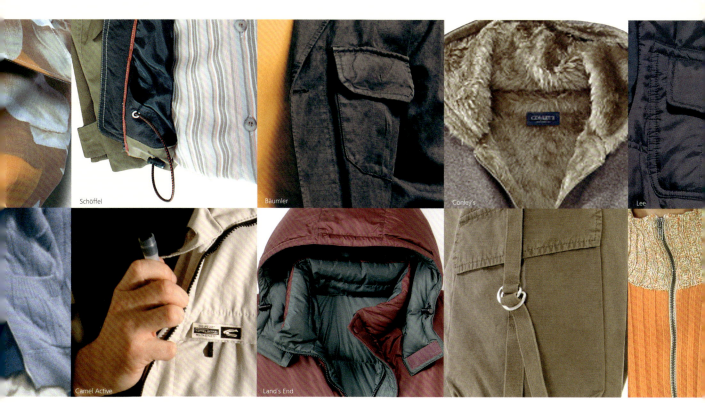

Schöffel

Bäumler

Conley's

Lee

Camel Active

Land's End

THE ANORAK

The anorak is a tried-and-proven functional jacket. It originated among the Inuit people of Greenland (Inuit: *anoraq*). Originally, the anorak was an overshirt made of fur with a tie clasp at the throat. The Scandinavians adopted it as well. The anorak experienced its fashion breakthrough in the 1930s, triggered by the 1936 Olympic Games in Garmisch-Partenkirchen during which the athletes wore this practical jacket. At this time, the anorak was already outfitted with a zipper extending from top to bottom, a hood with drawstring, and large slit pockets on the sides. The winter athletes' sporty functional clothing became a fashion item that has yet to loose any of its popularity. It is a continually rediscovered theme for designers and has undergone many changes and improvements in terms of cut, functional accessories, and materials over the course of time and changing fashion. In the 1950s and 1960s it was lined with plush and topped with fur-trimmed hoods. From the late 1970s onward, it was lined with down and boasted a quilted look. The current look is dominated by high-tech materials and modern processing techniques as well as stylish accents from earlier periods.

Anorak from 1953 with detachable hood, separable zipper, button-down pocket flaps, and a wide, quilted elastic waistband.

Camel Active

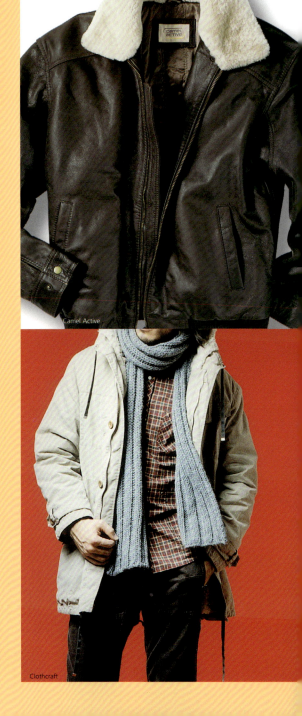

Camel Active

Clothcraft

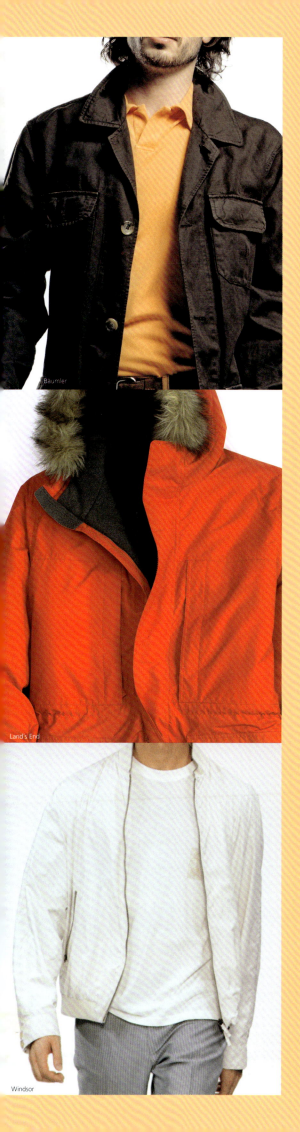

Bäumler

Land's End

Windsor

THE BLOUSON

The hallmark features of the conventional blouson are the knit wristband and zipper. According to legend, it originated from a kind of cotton overshirt which the crusaders wore over their metal armor to protect themselves from the burning sun. In the 1930s, the blouson was definitely regarded exclusively as a sports jacket in Europe. During the war, it became part of the soldiers' uniform and was later developed into civilian clothing. A close relative of the classic blouson is the lumberjack, the work jacket of North American woodcutters.

The lumberjack. With flat collar, knit wristbands, breast pocket, and zipper; 1953.

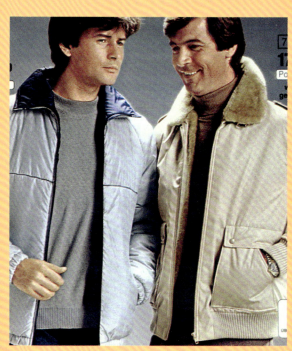

Anorak in blouson form with raglan sleeves, elastic wristband, and inside zipper pockets; bomber jacket with metal tabs on collar, reach-in and decorative pockets, and shoulder piece. Models from Witt and Weiden from the early 1970s.

Camel Active

Clothcraft

Falke

Bäumler

Jockey

Land's End

SHIRTS AND SWEATERS– THE PERFECT PARTNERS FOR SPORTS PANTS

Sweaters, zip jacks, T-shirts, and casual button-up shirts are always in style in leisure-time fashion. They are joined by styles which set special accents with elements borrowed from active sportswear. Men wear cargo and worker pants with sportswear shirts that are oriented to the adventurer or colonial style as well as knit and sweat jackets in the campus or trainer look. Button-up shirts and T-shirts are available in beach and holiday prints, and of course with lots of color, stripes and checks. Knit is casual in wide mesh, with styles turning nostalgic in winter. Flannel shirts are popular in the cold months in both solid colors and checks.

4351
5.80

The camping shirt. A product of 20th century leisure-time fashion.

49066
46.5

Merino

Sport sweaters from the 1960s with large patterns.

The Lumberjack Shirt

Warm flannel shirts call to life a classic that has occupied an established place in leisure-time fashion since the 1950s: the lumberjack

Camel Active

shirt. Kurt Cobain (1967-1994), founder, songwriter, and singer of the multi-platinum-record band Nirvana, wore it just as did American country singers from Dolly Parton to Johnny Cash. Relaxed, casual, and uncomplicated, the wool check shirt made its way out of the Canadian wilderness and into everyday wardrobes. After the Second World War, the warm shirt worn by lumberjacks, hunters, and cross-country runners was discovered by American college students. Paired with a T-shirt, jeans or khakis and topped with a leather jacket, it became the American style leisure-time outfit.

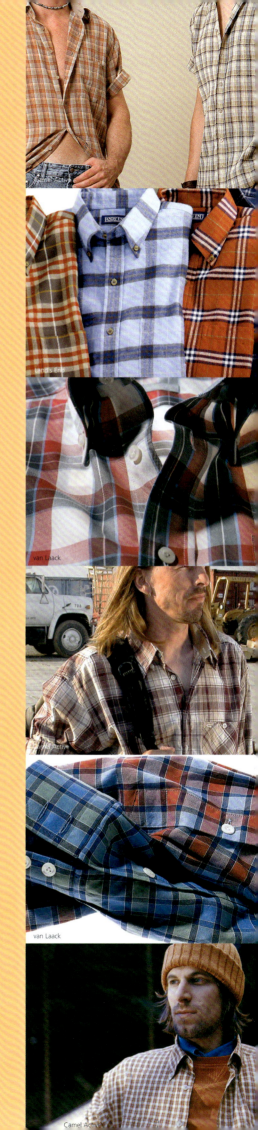

The Hawaiian Shirt

After the Second World War, another shirt appeared from the entirely opposite geographical direction and its popularity remains undiminished until today: the Hawaiian shirt. Often laughed at, it has nonetheless always had a stalwart group of fans. Although often few in number, they are happy to put this colorful piece of clothing on display in the warmer months of the year.

In the 1940s the Hawaiian shirt or aloha shirt, as it was known in the U.S.A., became the epitome of the leisure-time shirt. American tourists and members of the military brought the colorful shirt, printed with scenes of flora and fauna, back with them to their homeland.

Ellery Chun from Honolulu is regarded as the father of the Hawaiian shirt. In search of a new way of making a living during the depression, he hit upon the idea of combining Western shirts with Polynesian colors and symbols. He sold the first shirt of this kind for $1.95 in 1933. The shirt became popular on the European continent at the latest in 1953, with the release of James Jones' international hit movie filmed in Hawaii *From Here to Eternity*. It was during this time that both Americans and Europeans decorated their upper bodies with exotic patterns and reveled in dreams of a tropical paradise. Wistful South Seas music and Caribbean films abounded—even Elvis filmed several movies on Hawaii. In the 1960s, the Beach Boys and in the 1980s, the television series *Magnum* with Tom Seleck brought the Hawaiian shirt to new life.

Hawaiian shirts provide a continual source of inspiration for designers. Men can now again swath their upper bodies in a rainbow of color with holiday and beach prints. It is likely, however, that they will never have the chance to luxuriate in the plethora of patterns, colors, and exotic designs seen in the old days.

The Hawaiian shirt took on social significance with the show Magnum, at the latest.

The Bermuda Triangle, which acquired its name through unexplained plane and ship wrecks, extends over the Atlantic Ocean between Florida, Hispaniola and the Bermuda Islands.

PANTS FOR LEISURE TIME

The proceeding chapters have discussed the history, styles, and materials of men's pants. Beside jeans—a true masterpiece of versatility which can be paired with anything except for-

have been a self-governing British crown colony since 1684—found himself sweating so profusely in the subtropical climate that he simply cut off a part of his pants made of

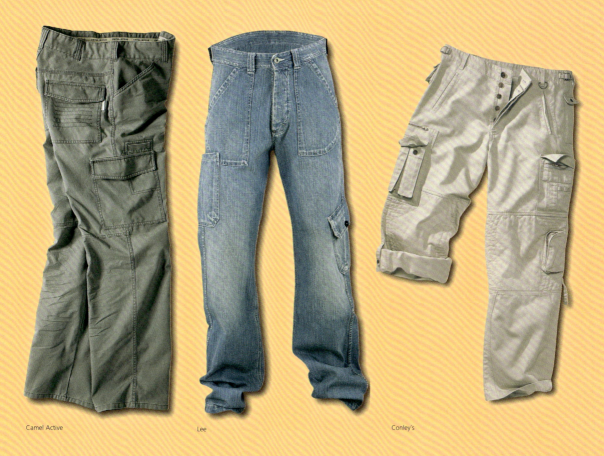

Camel Active

Lee

Conley's

mal business attire—men wear worker, cargo, and stylish jogging pants with sporty leisure-time outfits. A variety of pockets, drawstrings, and adjustable hems provide functionality. The selection is not limited to long pants either. Men can finally wear short pants as well. Short pants end between the thigh and knee and are known as shorts or bermudas. Typical bermudas have straight pant legs that end around the knee. These pants are, in fact, named after the group of islands in the Atlantic Ocean. There is a small, amusing story about how these pants acquired their name. Supposedly, an envoy of the English Queen on an inspection trip—the Bermudas

heavy English cloth. What is certain is that bermuda shorts in bright prints and striking colors were popular among Americans as beach pants in the late 1950s. Later, in slightly altered form, they would become general casual clothing items. While we are on the subject of knee-length pants, we should also mention one of the most famous examples: knickerbockers. In contrast to bermudas, knickerbockers end in a tight-fitting band at the knee. They are yet another example of the strange ways in which items of clothing get their names. The protagonist of this anecdote is the New York author Washington Irving (1783-1859). In his novel *A History of*

Marc O'Polo

WITT Weiden

Bermuda pants and shorts—a favorite summer outfit. These pants are reserved exclusively for leisure time and do not belong in the business world.

New York, published in 1809, he describes the Dutch immigrants' leisurely way of strolling along the bustling streets of the American

Knickerbockers, pants with a history.

metropolis in their typical knee breeches. Irving wrote the story, one of the most important works of American literature, under the pseudonym Dietrich Knickerbocker. When knee breeches became popular for bicycling and hiking in the late 19th century, the name *knickerbockers* was applied to all knee breeches.

Shorts are generally shorter than bermudas and knee breeches. The leg pieces extend down to the thighs. In the 1960s, they became increasingly popular as leisure-time pants. Whether bermudas, knicker-bockers, or shorts, men

Kickerbockers from the 1960s with drawstring, piped and hip pockets as well as knee bands with adjustable clasps.

do not wear short pants for business occasions nor in the urban city look. These pants are exclusively reserved for casual leisure-time outfits.

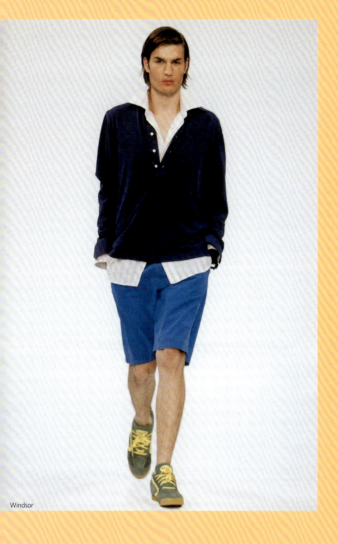

Windsor

Camel Active

Pringle of Scotland

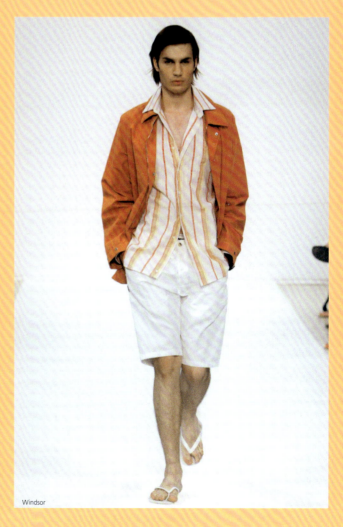

Windsor

CAPS

Caps have had a long-standing place in fashion with the sporty look. Pop singers, movie stars, and influences from the world of sports

have ensured a strong market presence for this decorative head covering. Fishermen's and skater caps, balloon caps and baseball caps are part of the perfect leisure-time outfit all over the

The classic cap for the well-groomed man.

world. And it is not just youth who are covering their heads. Even the over-forty age group, the so-called best agers, are fond of the sporty accessory.

Fishermen's caps are knit caps with a turn-up rim. They were originally worn by fishermen, sailors, and dock workers to protect them from the cold and wind. A competitor to the

Skater-style knit cap.

fishermen's cap is the so-called skater cap. It is usually a smooth knit cap without a turn-up rim. The balloon cap likewise originated in the working classes. This balloon-like headgear consists of several stripes that run together at the top, where they are crowned with a decorative button. The visor is freestanding and can be worn in different directions, depending on taste. This also holds true for the visor of the baseball cap, which became the favorite headgear for young people in the 1980s. It was introduced

as a sports cap in America more than 150 years ago by the players of the New York Knickerbocker Baseball Club. Back then it didn't look quite like it does today. The stiff visor and the adjustable strap with rubber knobs at the back were added to the cap much later. In a certain way, the baseball cap is similar to jeans or the T-shirt. People of every age group and social class feel an affinity with it. They wear it with a variety of outfits on many different occasions, depending on style and taste. They also use the caps as a medium of communication for literally spreading messages. The headpiece of the baseball cap is adorned with logos from trendy sportswear manufacturers and designer labels, and sports a wide variety of slogans. Any chapter on head coverings must also make mention of the bandanna (Sanskrit: *bandha* = pull closed), even though the square clothing that was originally used less as a head covering and more as a neck scarf, mouth covering, or sweat band, it is not really a cap but just a cloth. Tied around the neck or in front of the mouth, the bandanna is reminiscent of the American pioneer days and immortal Western stars like John Wayne. The bandanna was introduced to America during the age of George Washington in the second half of the 18th century. Before that, the British and the Dutch had imported the cloth from India. In the early 1980s, the bandanna became a popular head covering among fans of different street sports. From there it found its way onto the fashion scene as a

There are many ways to wear a rolled bandanna.

decorative head covering, printed with motifs or ethnic patterns such as paisley. The bandanna is now also available in slightly altered form: produced as a fabric tube, it can easily be worn in a variety of ways around the neck or on the head for protection or just for looks.

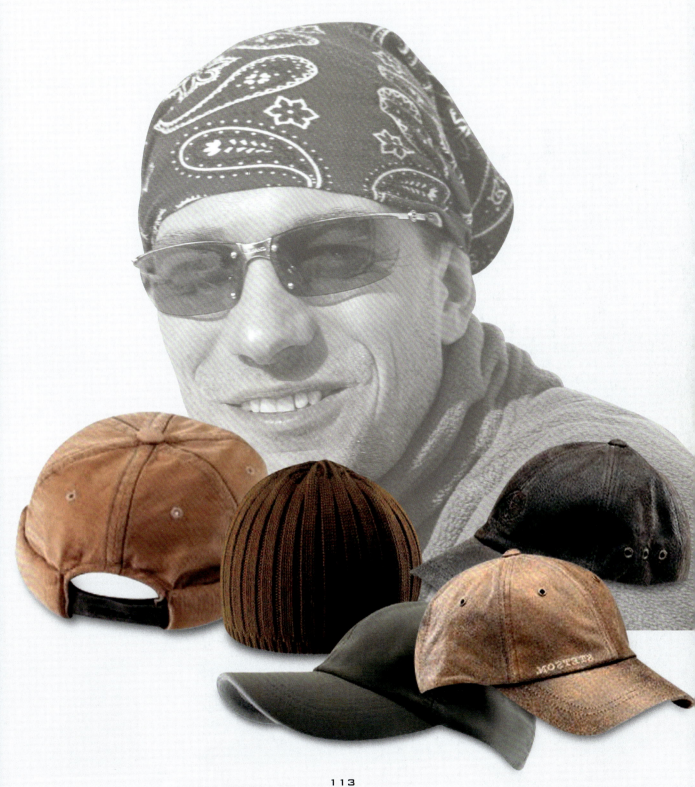

SPORTY SOLES

Sturdy boots or ankle boots, sneakers or moccasins, sandals or flip flops. Men have a wide variety of opportunities for adding the perfect shoes to their casual, sporty outfits, entirely in keeping with their personal taste and standards.

One trendy shoe popular with all age groups is the sneaker. The term sneaker, derived from the quiet way of walking, appeared for the first time in 1875 and referred to a croquet shoe designed which was in America and was made of white canvas and a rubber sole. The rubber sole was a product of the newly invented vulcanization procedure. The

Burlington

Ever-popular sneakers paired with Burlington socks in the pattern now famous all over the world.

method of attaching upper material such as linen with the rubber sole was an invention of the New Yorker Wait Webster, who had his technique patented. The sneaker underwent many changes until it became fashionable among teenagers in the 1960s. Today, there are sneakers for all ages and style preferences, as well as in all price categories, ranging from models off the rack for the normal man to handmade luxury sneakers.

Sports shoes are now an integral part of the world of fashion. The sneaker has long since moved out of an exclusively sports-oriented environment. It is no longer a smelly, sweaty sports item, but a socially acceptable casual shoe.

All Stars from Converse are sneakers that have meanwhile acquired cult status. All Star is not just a label, it is a part of the company's philosophy. The American company Converse

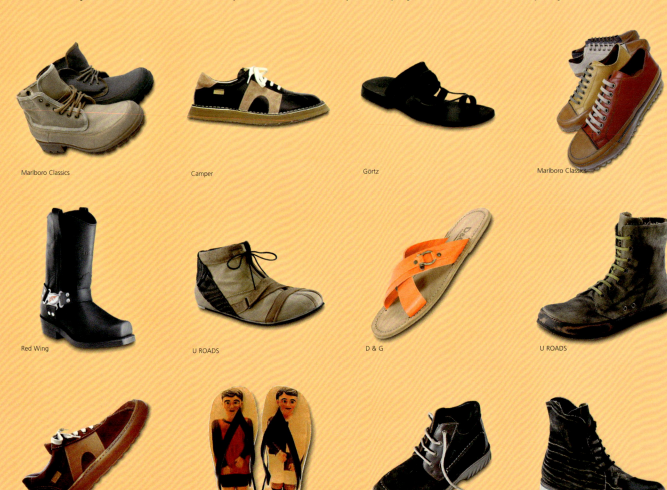

Marlboro Classics

Camper

Görtz

Marlboro Classics

Red Wing

U ROADS

D & G

U ROADS

Camper

Camper

Camel Active

U ROADS

Lottusse

Görtz

Görtz

U ROADS

Görtz

Red Wing

U ROADS

Red Wing

contracts the most famous athletes of the day for its advertising campaigns. In the past, these stars have included Dennis Rodman (1997), Magic Johnson (1984), Julius Erving (1970), Jack Purcell, and Chuck Taylor, who made the All Stars shoes famous in 1920 as a

Converse sneakers have acquired cult status.

basketball shoe. The ankle-high lace-up shoe became a part of everyday fashion in the 1950s and has retained its high level of popularity until today.

Those who don't like the sporty, lightweight shoes can wear simple lace-up shoes, moccasins, or boots. Dr. Klaus Maerten, a country doctor from Bavaria, couldn't have imagined what an impact the boots with air-cushioned soles which he invented in 1945 would have. Nor could the British shoe manufacturer Bill Griggs, who produced the boot with the air-wear technology, as the sole was called, in England. In the 1970s, English punks claimed

Invented in Bavaria, worn all over the world: the Doc Marten.

the Doc Marten as their own, smoothing its way into the pop and rock scene. Transformed into a universal fashion item, the lace-up boot was worn by adherents of widely varying social, political, and sexual persuasions. Doc Marten are no longer as trendy as they once were, but they have retained their reputation as comfortable walking shoes.

Sandals or backless slippers—by all means without socks—are perfect for the hot times of the year. Flip flops and open-toe sandals are also currently experiencing a strong comeback after spending many years being limited to beach,

Out of the closet and onto the street: the flip flop.

vacation, or garden shoes. They can now be seen not only on the major beaches of the world, but in cities everywhere.

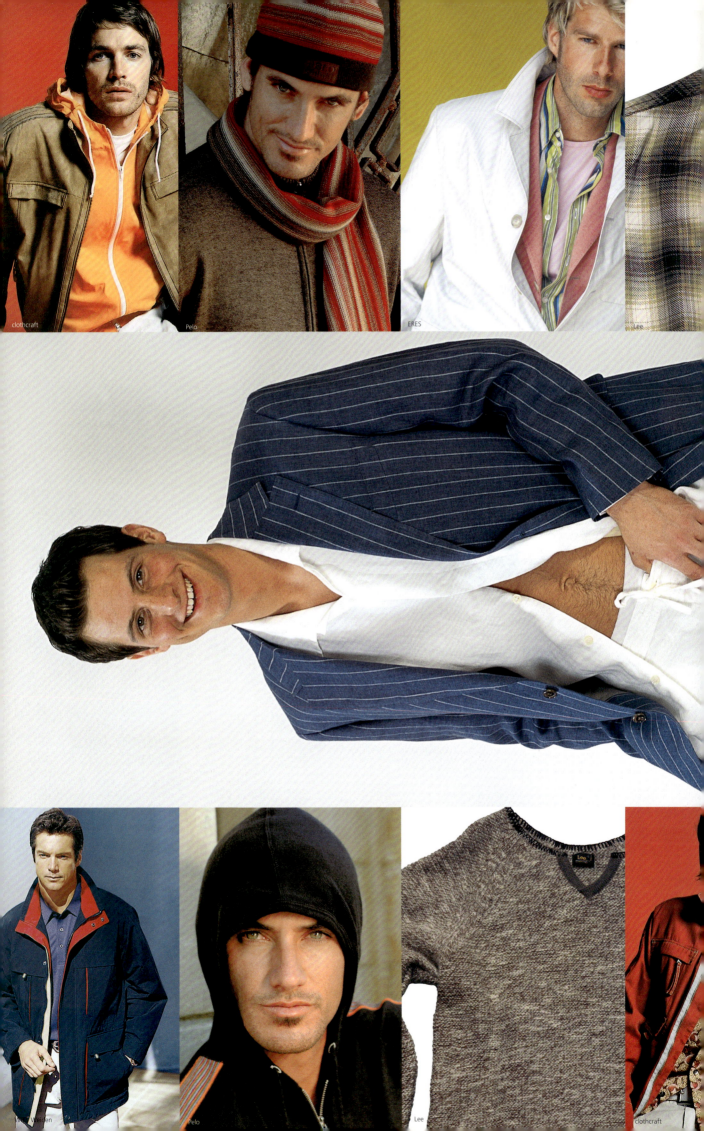

clothcraft

Pelo

ERES

Lee

clothcraft

Lee

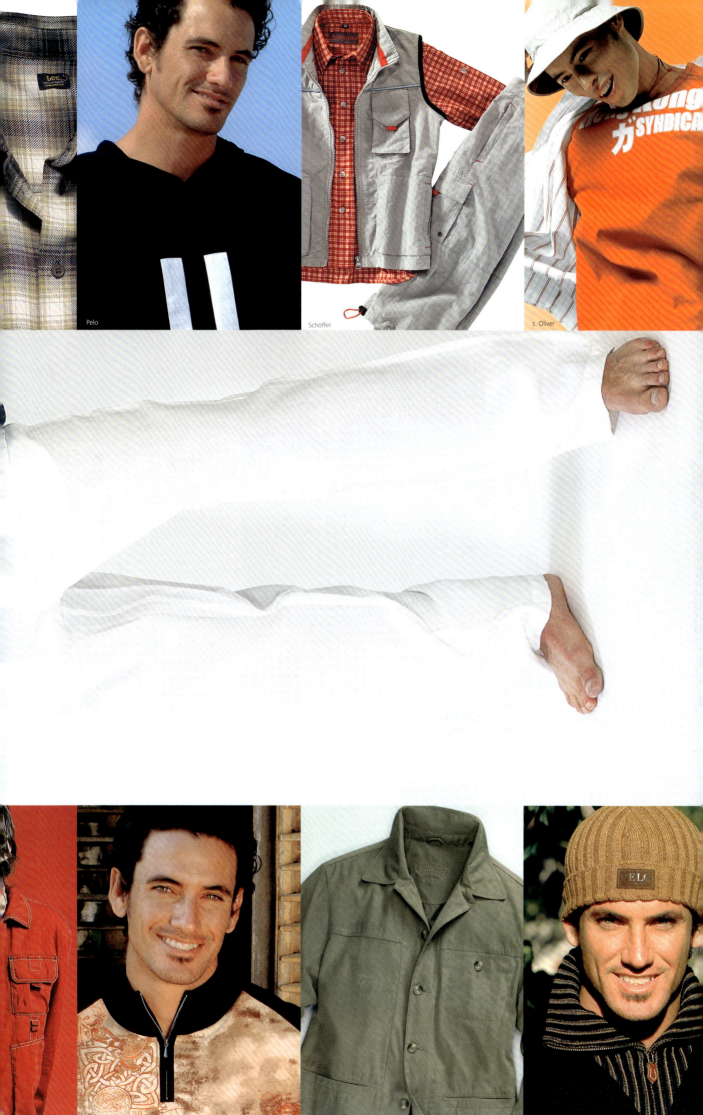

Pelo

Schöffel

s. Oliver

WITT Weiden

Pelo

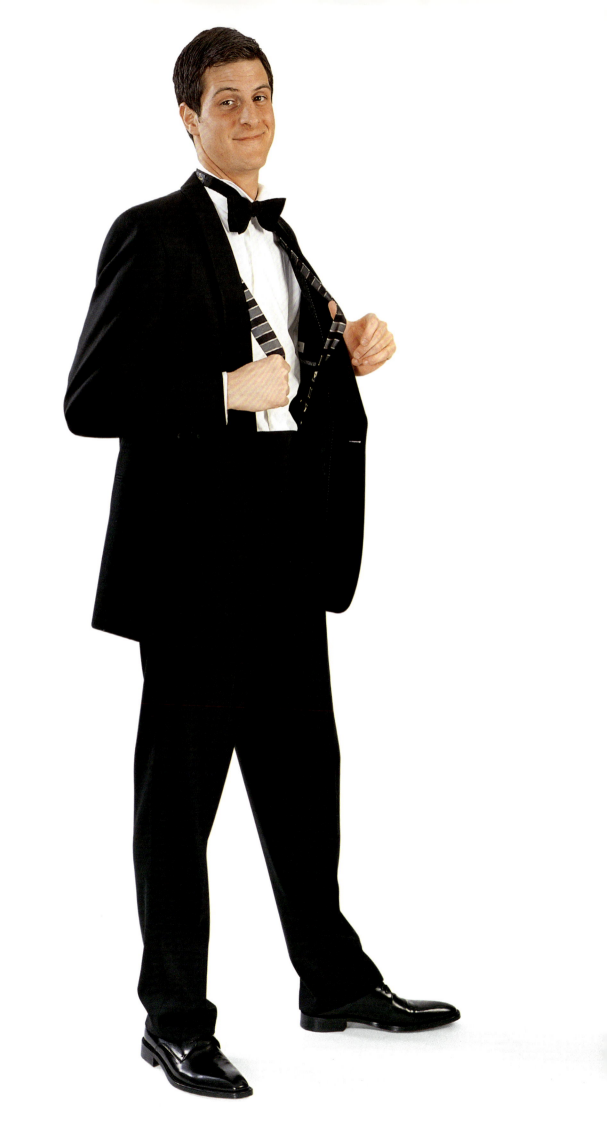

IMPRESSIVE ELEGANCE

6

EXTRAORDINARY CLOTHING FOR EXTRAORDINARY OCCASIONS

Special occasions call for very special styling. Admittedly, such occasions are seldom if one doesn't happen to be a politician or an ambassador. Perhaps an invitation to a special event, a festive evening dinner, or a glamorous reception is looming in the none-too-distant future, however. Or you are planning to get married—reason enough to devote serious consideration to the appropriate outfit for the occasion.

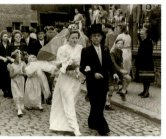
Marrying in style. Wedding in tailcoat, 1949.

If the host expects the guests to wear certain clothing, this will always be indicated on the invitation. *White tie* or *cravate blanche* refers to the full dress suit, the tailcoat. *Black tie* or *cravate noire* refers to the dress suit. In the U.S.A. this suit is known as a tuxedo, in England it is called a dinner jacket. It should not be confused with what Germans call the dinner jacket and which is known as the white dinner jacket in England.

The Tailcoat

The tailcoat is the most elegant piece of clothing a man can wear. It is the king of evening suits. The tailcoat became an evening-only suit when it was replaced by other forms of suits such as the cutaway as a daytime suit in the mid-19th century. Since then, changes in form have been for the most part limited only to fashionable details. During the Biedermeier period (1815-43), when the tailcoat was still a daytime suit, it was worn in tobacco brown, bottle green, and violet blue and often had a lining in a

different color. Today, the tailcoat is worn only in black. The characteristic hallmarks of the tailcoat include a short upper part extending to the waist with silk-covered lapels, tails in the back—the so-called swallow tails—which are connected with the upper part of the coat through a horizontal seam in the waist, as well as double silk stripes on the side seams of the pants. The jacket is always single-breasted and cannot be closed. The tailcoat is worn with a white vest made of piqué, a white dress shirt with fold-over collar and plain cuff links, black silk socks, and patent leather shoes as well as a white bowtie. The bowtie should always be hand-tied and should not be of another color. Black ties are part of a waiter's professional clothing. As the crowning touch, daring men can add a top hat.

The Tuxedo, or Dinner Jacket

The tuxedo, or dinner jacket, is a suitable alternative to the tailcoat. This suit is also reserved as eveningwear. According to legend, it was invented by the Duke of Sutherland. In German, it is called *Smoking*. The name supposedly comes from the fact

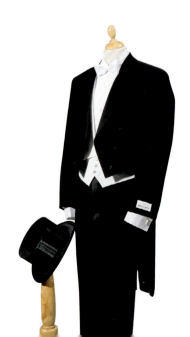

that when British gentlemen visited a smoking parlor, they liked to don a jacket which had a formal and festive character similar to that of the tailcoat. It is not clear why the name "smoking jacket" did not become wide-spread in the country of origin, Great Britain, where the suit is now called the dinner jacket. In the U.S.A., on the other hand, this jacket is known as the tuxedo. This is because the tuxedo jacket was first worn in the U.S. during the exclusive opening of Tuxedo Park, a recreational area near New York, in 1886.

The tuxedo is worn in blue or black, the shawl collar or the lapels are lined with silk, the straight pants with silk stripes. According to taste, the tuxedo can be worn with a cummerbund or vest, the color, fabric, and pattern can be selected at will but should not exceed accepted fashion boundaries. The white dress shirt with hidden button panel is obligatory, versions with embroidery or ruffles do exude a certain charm. The bow is black or color-coordinated with the vest or the cummerbund. The outfit is completed with black shoes in a high-quality, smooth leather and fine silk socks.

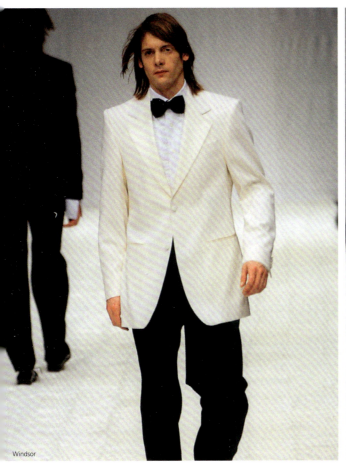

Windsor

Windsor

The Cutaway

The cutaway, also known as a morning coat or morning dress, is a must at the annual Royal Ascot horse races. It is the daytime dress suit. It is worn to official occasions and conferences or to weddings in blue and gray.

A cutaway usually calls for a gray top hat. Men wear this outfit at the Royal Ascot, which takes place every year in June.

It stems from the classic frock coat. An inventive English tailor in the late 19th century is said to have cut off the straight front edges of the frock coat in order to give the jacket additional shape and emphasize the pants more. This small story also explains the jacket's name. The cutaway is never worn with pants of the same color but with pants of a different color, usually striped trousers. It is accompanied by a white collared shirt, a pearl-gray vest, a silver-gray normal tie or one which covers more of the chest and is tied in an elaborate knot, as well as classic black shoes such as Oxfords. The cutaway should never be worn with a bowtie or in the evening. Like the tailcoat, the top hat provides the perfect finishing touches.

White Dinner Jacket

A white dinner jacket is perfect for weddings, elegant summer parties, a balmy night on the high seas, or a cocktail party. The color of the jacket differs from that of the tuxedo or regular dinner jacket; otherwise, all other items of clothing and accessories worn with the white dinner jacket are the same.

The dinner jacket is a classic for many social occasions.

Of Bowties and Dragonflies—The Tie

You either love them or hate them. Any man who wears them, a seldom sight today, can be sure of being noticed. Most men prefer a necktie and you rarely see a bowtie with a normal daytime outfit. The bowtie is closely related to the necktie. Both originated from the neckband or the neckerchief. When the necktie appeared in the 19th century, the bowtie also assumed its own independent identity. A large number of variations for tying bows and knots have been developed over time. There is for example the Lipton bow, named after the English tea giant Sir Lipton; the butterfly bow named after Puccini's opera *Madame Butterfly*; as well as the bowtie or the dragonfly. The latter

An elegant outfit should be accompanied by cuff links. Matching shirt buttons are also available.

The Cummerbund

At first glance, some pieces of clothing and accessories tempt us to wonder about their origin. The cummerbund is definitely one of them. Many Germans will have spent quite a while wondering how the *Kummerbund* (the German word for cummerbund) was connected to *Kummer* (the German word for sorrow and grief). The term comes from the Hindustani language in which the *camarband* is a colorful waistband and used to be one of the most important pieces of clothing after the turban. The English have been familiar with the folded belt since the late 19th century. It first became popular on the European continent in the 1930s.

became fashionable in the 1950s. With long, narrow wings and a small knot, it made the bowtie popular with daytime suits once again. It is often conjectured that the reason the bowtie is so seldom seen is the male gender's lack of manual dexterity. In fact, few men really do know how to tie a bowtie correctly. Yet it is no more difficult than tying a necktie. Ready-tied bowties are naturally also available as well. Men who want to prove their sense of style, however, should learn how to tie a bowtie, firstly, because a ready-tied bowtie only looks half as good, if even that, and secondly, because a bowtie is mandatory for both a tailcoat and a tuxedo. Every man should try wearing a bowtie at least once. Some will notice how becoming a bowtie can be and how it can flatter the face—after all, the right combination is the only important factor.

The cummerbund covers the transition area from the waistband of the pants to the shirt. It is worn with the fold on the top.

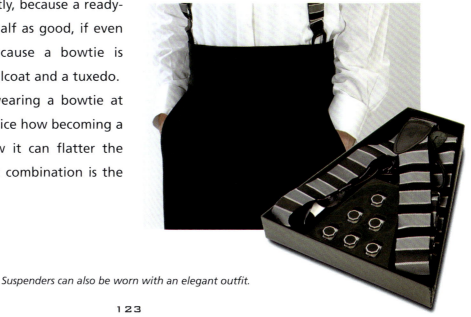

Suspenders can also be worn with an elegant outfit.

The Top Hat

In the 19th century, fine gentlemen always wore a top hat. It was worn during the day or in the evening in a variety of fashionable shapes and colors. Men wore a matte or light green top hat with a business suit or cutaway, while a black, high-gloss top hat was perfect

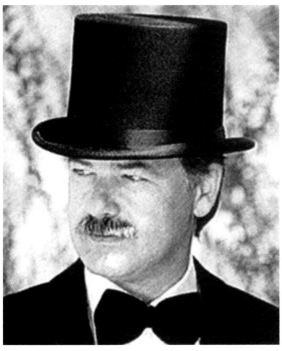

The black top hat used to be an essential part of eveningwear. Men no longer wear it today, with the exception of very official and festive occasions.

for eveningwear. Since the 1950s, the top hat has only been worn to very official or very festive occasions such as one's own wedding, when, paired with appropriate clothing, a top hat ensures an impressive presence. Men are not allowed to attend the royal horse race in Ascot when not wearing correct morning dress—and this includes the top hat. Hard as it is to believe, the top hat's introduction to the world of fashion was not at all festive, but more of a public annoyance. The English hat maker John Hethering is said to have worn the top hat in public for the first time in 1797. According to this story, Hethering attracted so much attention with his unusual head covering that the public authorities arrested him and charged him to

a substantial fine for violation of the peace. When it comes to the history of the top hat, mention must also be made of the *chapeau claque* (French for folding hat), called the gibus hat after its creator and later known as the opera hat. In 1823, the hat maker Gibus registered a patent for this type of top hat, which could be collapsed by a spring mechanism. The Parisan hat maker Duchêne improved the system with a pneumatic spring so that the hat could be folded and straightened out again with pressure. The *chapeau claque* was worn with a tailcoat in ballrooms and theaters until the beginning of the 20th century.

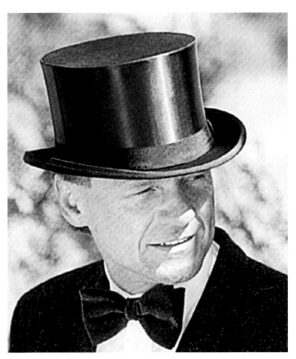

A hat shrouded in legend: the chapeau claque.

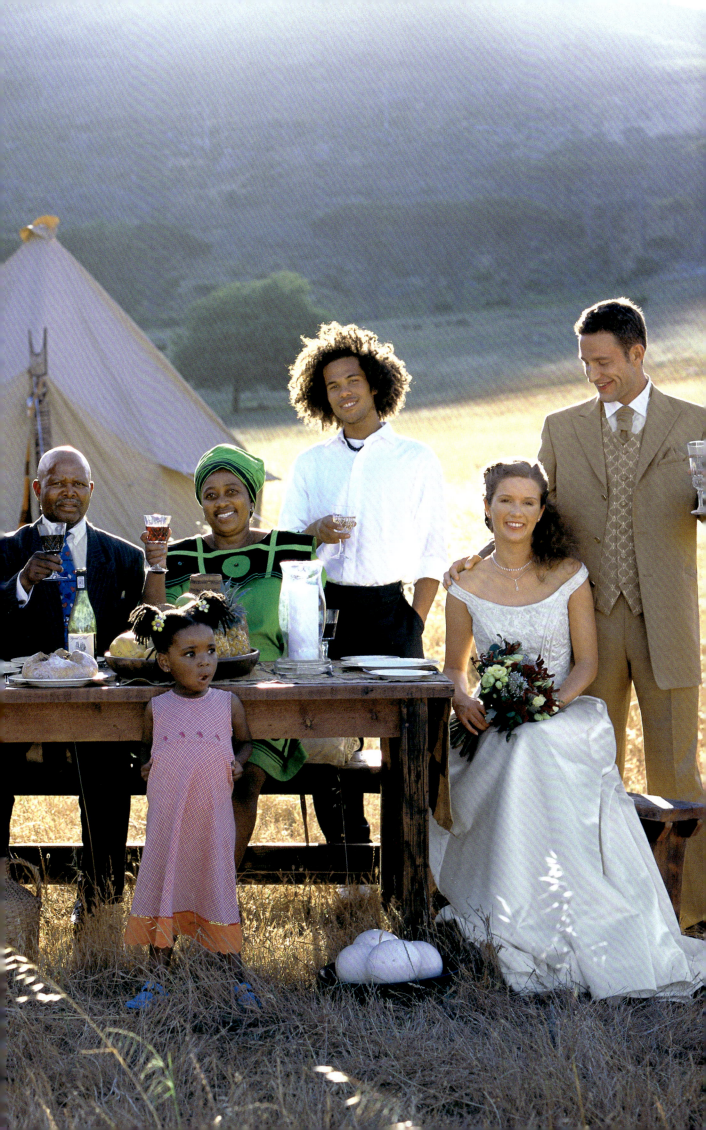

From A to Z

Active sportswear / activewear
Term for all clothing used when practicing active sports.

All-over pattern
Pattern covering the entire surface of the material.

Applications
Ornaments that are sewn or glued on.

Arctic look
Sportswear look, functional jackets generously lined with fur or fake fur.

Aviator jacket
Short jacket reminiscent of pilots' uniforms. Typical features: zipper, knit wrist- and waistband, collar, slit pockets.

Bellows pockets
Sewn-on pockets with embedded folds in the inside of the pocket. This enables them to hold more.

Bermudas
Knee-length shorts.

Bi-color
Two-colored yarns, threads, colored fabrics, and print designs.

Biker jacket
Tight-fitting, usually waist-length jacket in the motorcycle jacket style.

Campus look
Sportswear style oriented to the clothing of American college students.

Cargo pants
Wide, working style pants. Patch pockets on the pant legs are a characteristic feature.

Casual sports style
Casual clothing with elements of sports clothing.

Casual style / sportswear
Casual but not sloppy clothing. A counterpart to formal, correct clothing.

Chalk stripes
Fine stripes in a napped fabric with a blurry appearance.

Clean
Clean or smart style.

Club style
Fashion oriented to club uniforms.

Color blocking
Pairing of colored surfaces to create striking color contrasts.

Combat pants
Pants in extreme military style.

Corduroy
Corded velvet, the ribs can be narrow or wide or both.

Cross-dressing
A mix of clothing styles.

Crushed fabrics
Woven fabrics with an irregular, wrinkled surface.

Donegal
Carded yarn tweed with a hand-woven character, made of irregular, carded yarns.

Drawstring
Belt running through the inside of a garment for regulating its width.

Ethno style
Clothing with colors, patterns, and forms typical of foreign cultures.

Fearnaught
Typical, voluminous wool fabric for coats and winter jackets.

Fishbone
Lengthwise fabric pattern. Resembles shape of fish bones.

Five pockets
Sports pants without pleats, with two slit pockets in the front, two hip pockets in the back and a small pocket for money.

Flannel

Fabric made of wool, wool blend, or viscose with a soft texture and napped top or bottom side.

Flat-front pants

Pants with a smooth front, narrow and without pleats.

Fleece

Strongly napped look, often made of knitwear.

Glencheck

Woven design; pattern usually has a base check and a top check.

Jodhpur pants

Riding pants that are wide in the thighs and tight in the knees.

Jogging style

Casual, jogging-style clothing. Typical features include hoods, drawstrings, and elastic waistbands.

Melange

Yarns and threads made of two different-colored fibers.

Military look

Sporty style derived from modern-day uniforms.

Moleskin

Thick cotton fabric; napped on the left side.

Mouliné

Thread or yarn made of at least two different dyed yarns.

Nappa leather

Collective term for leather with a smooth surface.

Norwegian pattern

Knit pattern with two or more colors. Typical patterns include ice crystals, reindeer, and Christmas trees.

Paisley pattern

Oriental pattern.

Pipe trousers

Narrow pants without pleats.

Plus-fours

Long, wide pants with a tight band.

Retro sports look

Fashion derived from the traditional clothing of certain European sports (cricket, tennis, sailing).

Shirt jacket

Loose-fitting, unlined jacket with shirt collar. Also has a patch breast pocket, shoulder yoke, and cuffs.

Slacks

Strait, wide pants without turn-up cuffs; usually with pleats.

Sportswear

Sporty leisure-time clothing resembling active sports clothing.

Velour

Knitted, elastic plush.

Vintage look

Purposefully faded, torn or tattered look.

Acknowledgements

We would like to thank the following companies and institutions for their friendly support:

Burlington – Asics – atelier torino – Bäumler – Bugatti – Camel Active – Camper
Cinque – Clothcraft – Conley`s – DAKS – Deutscher Sportbund – ERES – Falke – Feraud – Giesswein
Goldpfeil – J. Ploenes – Helly Hansen – HOM – Hubert Gassenschmidt – hutshopping – Kunert – Jaques Britt
Jockey – Koil – Lands' End – Lee – Levi Strauss – Lottusse – Görtz – Marc O`Polo – Marlboro Classics
Mey – Odermark – Olymp – Pelo – Olaf Benz – Manstore – Pringle of Scotland – Proscott Golftours – Red Wing Shoes
s. Oliver – Schiesser – Schöffel – Seidensticker – Siemens-Electrogeräte GmbH – Strenesse Gabriele Strehle – U Roads
van Laack – Westermann – Wilvorst – Windsor – WITT Weiden – Wolford

Special thanks to our model Marco

Picture credits

The publisher would like to thank manufacturers, photographers, and archives for the reproduction permissions given by them. The publisher has made all efforts to trace the owners of publication rights.

© Birgit Engel: 21, 28, 32, 34, 42, 46, 73, 81, 90, 96, 97, 112, 113, 115, 120;
© Werner Stapelfeldt: 8, 12, 13, 16, 19, 20, 25, 28, 29, 35, 36, 37, 38, 39, 43, 46, 49, 51,
52, 57, 58, 61, 65, 67, 71, 74, 75, 84, 98, 100, 106, 114, 116, 117, 118, 121, 122, 123;
© Rupert Tenison: 50; © Dieter Wichmann: 34

© Arlington GmbH & Co.KG: 19, 71, 79, 114; © Asics Deutschland GmbH: 92, 93, 96, 97; © Bäumler AG: 27, 29, 32, 54,
55, 59, 82, 100, 101, 103, 104; © Brinkmann Gruppe: 27, 29, 44, 45, 59, 115, 116; © Camel Active: 44, 59, 67, 83, 100, 101
102, 104, 105, 108, 111, 114; © Camper: 20, 82, 114; © Cinque: 26, 44, 45, 59; © Clothcraft: 102, 104, 110;
© Conley´s Modekontor GmbH: 54, 82, 100, 101, 108; © DAKS: 26, 55, 56 © Deutscher Sportbund: 92; © Falke KG: 47, 70
78, 79, 80, 81, 94, 104; © Hubert Gassenschmidt: 86, 87; © Giesswein AG: 20; © Goldpfeil GmbH: 28, 29;
© Helly Hansen Deutschland GmbH: 88, 89, 90, 91; © HOM: 13, 17, 66; © Hudson-Kunert Vertriebs GmbH: 47, 80, 81;
© hutshopping: 76, 86, 90, 113, 122, 124; © interair GmbH Sport- und Incentive Reisen Laufend die Welt erleben: 92-93
© Jacques Britt Internationale Moden GmbH: 33; © Jockey: 104; Josef Witt GmbH: 10, 15, 18, 24, 56, 57, 60, 70, 91, 102,
103, 104, 110, 112, 116, 117; © Land´s End GmbH: 19, 21, 61, 100, 101, 103, 104, 105; © Lee: 54, 62, 63, 64, 73, 83, 101,
108, 116; © Levis Strauss & Co.: 64; © Lottusse: 48, 49, 51, 81, 83, 115; © Ludwig Görtz GmbH: 49, 51, 114, 115;
© Marc O´Polo: 68, 110; © Marlboro Classics: 59, 77, 80, 82, 83, 114; © Gebrüder Mey GmbH & Co KG: 13;
© Odermark Bekleidungswerke: 27; © Olymp Bezner GmbH & Co.KG: 33, 68, 69; © Pelo Men´s Fashion: 68, 69, 116, 117
© picture-alliance/akg-images: 76; © picture-alliance/KPA Honorar & Belege: 72, 107; © Hans Ploenes GmbH: 17, 32, 35,
40, 41; © Premium Bodywear AG: 13; © Pringle of Scotland: 59, 68, 69, 70, 111; © Profil PR: 83;
© Proscott Golftours GmbH & Co.KG: 87; © Red Wing Shoes Company Inc.: 83, 114, 115; © s. Oliver: 44, 117;
© Schiesser AG: 11, 13; 15; © Schöffel Sportbekleidung GmbH: 86, 91, 100, 101, 117; Seidensticker GmbH: 19, 30, 31, 32
66, 69; © Siemens-Electrogeräte GmbH: 21; © Strenesse AG: 55, 82; © U ROADS: 114, 115; © van Laack GmbH: 32, 33, 40
68, 105; © Westermann Schulbuchverlag GmbH: 109; © Wilvorst-Herrenmoden GmbH: 122, 125;
© Windsor Damen- und Herrenbekleidung GmbH: 26, 44, 45, 49, 51, 55, 70, 71, 81, 82, 83, 103, 111, 121; © Wolford AG: 95

Frontcover: © Ruprecht Stempell

Websites

www.burlington.de, www.asics.de, www.baeumler.com, www.hutshopping.de, www.bugatti.de, www.camelactive.de,
www.camper.es, www.cinque.de, www.clothcraft.de, www.conleys.de, www.daks.com, www.FALKE.com,
www.feraudhomme.de, www.giesswein.com, www.goldpfeil.de, www.interair.de, www.ploenes-krawatten.de,
www.hellyhansen.com, www.hom-fashion.com, www.gassenschmidt.de, www.kunert.de, www.jaques-britt.de,
www.jockey.com, www.koil.it, www.landsend.de, www.lee.com, www.levis.com, www.lottusse.com, www.goertz.de,
www.marc-o-polo.com, www.marzotto.it, www.mey.de, www.odermark.de, www.olymp-hemden.de, www.pelo.de,
www.olafbenz.com, www.manstore.com, www.pringlescotland.com, www.proscott.com, www.redwingshoes.com,
www.soliver.de, www.schiesser.de, www.schoeffel.de, www.seidensticker.de, www.siemens.de/hausgeraete,
www.strenesse.com, www.uroads.com, www.vanlaack.de, www.wilvorst.de, www.hochzeit-mit-wilvorst.de,
www.windsor.de, www.witt-weiden.de, www.wolford.com